STEICHEN: THE MASTER PRINTS 1895-1914

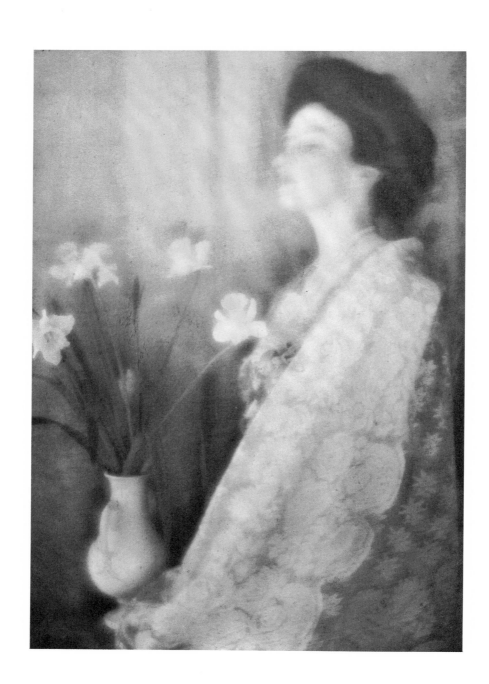

STEICHEN

THE MASTER PRINTS 1895-1914

THE SYMBOLIST PERIOD

Edward Steichen

D ENNIS L ONGWELL

The Museum of Modern Art, New York

Distributed by New York Graphic Society, Boston

Library of Congress Catalog Card Number 77–90995
ISBN 0–87070–581–4

Designed by James M. Eng and Stevan A. Baron
Type set by The Stinehour Press, Lunenburg, Vt.
Printed by The Meriden Gravure Co., Meriden, Conn.

The Museum of Modern Art 11 West 53 Street New York, N.Y. 10019

Printed in the United States of America

Frontispiece: *Young Girl Standing beside a Vase of Daffodils.* c. 1908
Philadelphia Museum of Art. Gift of Miss Mary Talbot

For my wife, Alicia

CONTENTS

ACKNOWLEDGMENTS

THIS BOOK IS PUBLISHED ON THE OCCASION of an exhibition at The Museum of Modern Art. An exhibition of prints as rare and valuable as these by Steichen could happen only through the generosity of those kind enough to lend irreplaceable works for an extended time. Most generous has been the staff of The Metropolitan Museum of Art, New York, through their willingness to part with approximately forty of the nearly seventy Steichen photographs in the Metropolitan's incomparable Alfred Stieglitz Collection. Without the enthusiastic cooperation of Colta Feller Ives, Curator in Charge of the Department of Prints and Photographs, and Weston J. Naef, Associate Curator, this project would have been impossible. Their kindness transcended professional courtesy and became an act of friendship for which I am deeply grateful. Weston Naef was especially thoughtful in sharing with me his ideas about these complex prints and the multiple processes that produced them, ideas derived from his long acquaintance with the works and his research into the entire Stieglitz Collection. His catalogue raisonné of this most important collection of Photo-Secession prints is eagerly awaited.

David Travis, Assistant Curator, and Miles Barth, Curatorial Assistant, of The Art Institute of Chicago were similarly generous in lending a number of works from the Institute's collection. My colleagues Ann Percy, Associate Curator for Drawings at the Philadelphia Museum of Art, and Mark Haworth-Booth, Assistant Keeper of Photographs at the Victoria and Albert Museum, London, offered valued additions to the works exhibited. Mr. and Mrs. Noel Levine of New York City and Mrs. Caroline Hammarskiöld of Stockholm made their prized works available with a readiness that was truly gratifying and deeply appreciated.

John Szarkowski, Director of the Department of Photography at The Museum of Modern Art, was kind enough to approve my proposal for the exhibition and offered helpful criticism of the essay introducing this book. Miss Grace M. Mayer, Curator Emeritus of the Steichen Archive of The Museum of Modern Art, was enormously helpful in guiding me through the vast store of information about Steichen's life and work contained therein. Her willingness to share knowledge drawn from a decade of research made my work easier than I could have imagined, and I am in her debt. Susan Kismaric, Research Supervisor, assisted ably and cheerfully in coping with the myriad details in the production of this

book. Peter Collins, intern in the Department of Photography, made the study prints that formed the basis of my research.

I would like to thank, also, Barbara Savinar of the Museum's Department of Registration, who skillfully assembled the prints for the exhibition; Lamia Doumato, Reference Librarian, who acquired research materials from distant libraries; and Richard L. Palmer and Mary Lea Bandy of the Department of Exhibitions, who so patiently coordinated the activities necessary to mount the exhibition. Paper Conservators Antoinette King and Trudy Schwartzman brought immense care to conserving and restoring several works to their original beauty.

The introductory essay was edited by Francis Kloeppel, and I am grateful for the challenging intelligence he brought to the task. Other material was edited by Jane Fluegel, a friend whose insight brought significant change to the form of this book. James M. Eng and Stevan Baron designed what I believe is an extremely handsome volume, and the latter also oversaw its production. I am grateful, in addition, to Don Dehoff and Philip Poggio of Meriden Gravure for the energy and skill they brought to the printing of this book.

I must acknowledge my gratitude to William Rayner and Diana Edkins of Condé Nast for permission to reproduce the Steichen work from *Vogue* magazine and to Donald Gallup and Miss Georgia O'Keeffe for permission to quote letters by Steichen in the Stieglitz Archive at Yale University. Richard Benson of The Fisher Press, Newport, Rhode Island, generously shared his thoughts with me about the complex techniques Steichen used to make his prints. My understanding of the richness and complexity of the Photo-Secession period was greatly enhanced by a series of seminars led by Rosalind Krauss at the Graduate Center of The City University of New York. I acknowledge my debt to her for the innumerable ideas that were so freely exchanged.

Finally, Joanna T. Steichen, whose generosity has been boundless, can never be sufficiently thanked for permitting her husband's works to be reproduced in this volume. I can only hope that it, and the exhibition it accompanies, will reward her kindness by reflecting in some measure the genius inherent in Steichen's earliest work.

D.L.

STEICHEN: THE MASTER PRINTS
1895–1914
THE SYMBOLIST PERIOD

Portrait of Steichen at age twenty-one, possibly photographed by traveling companion, Carl Björncrantz, during first voyage to France, 1900. Collection Mr. and Mrs. C. E. Björncrantz, Evanston, Ill.

Day: *The Seven Last Words:* *"Father Forgive Them: They Know Not What They Do."* 1898. Library of Congress, Washington, D.C.

"IT IS NEW, IN A SENSE, but only new as a school of photography, for it reflects clearly the style of a well-known school of painting, and that is why it has been accepted without the least difficulty by the enlightened portion of the French public—whether they are photographers or not—who have lived for several years in its special atmosphere."[1]

Robert Demachy, a wealthy French amateur photographer and critic, made these observations early in 1901 about an exhibition of American photographs then on view in Paris at "le Photo-Club." The exhibition, "Des oeuvres de F. Holland Day et de la nouvelle école américaine," presented 304 prints by thirty-five American photographers, the majority of whom are now forgotten. The star of the exhibition was a young man of twenty-one then studying painting in Paris, Eduard J. Steichen. His contribution of thirty-five photographs was exceeded only by the thirty-seven works from a Newark, Ohio, warehouse clerk, Clarence H. White, and those of the exhibition's organizer, Boston photographer and publisher of deluxe books F. Holland Day, who had seen fit to include eighty of his own creations, in a quarter of which he appeared as Christ.

Demachy did not identify the "special atmosphere" that permeated these works, probably because his readers were thoroughly familiar with it. At that time the magazines referred to it as "advanced" photography, "modern" in spirit. Today we can call it (and the school of painting to which Demachy so perceptively linked it) Symbolism—the most influential and widespread tradition in the art of the late nineteenth century.

Until recently, of course, the suggestion that the art of the Symbolist movement as exemplified by such French artists as Gustave Moreau, Odilon Redon, and Pierre Puvis de Chavannes could have influenced American artistic photography in the first decade of this century would have seemed incomprehensible, because Symbolism was itself so little known and appreciated. It now appears, however, that the traditional way of thinking about the evolution of modern art—Impressionism followed by Post-Impressionism, followed by Fauvism and Cubism—has greatly oversimplified the complex growth of the art of this century, and that the Symbolist movement, far from being ancillary, was in fact seminal to that growth.

In Steichen's case this issue has been complicated by the suggestion

in his autobiography, *A Life in Photography* (1963), that French Impressionism—Monet in particular—influenced his early landscapes.[2] A further complication arises from Steichen's apparent need to "justify" his early career by emphasizing his role as the innovator who, while living in France, arranged through Alfred Stieglitz's Photo-Secession gallery at 291 Fifth Avenue the first New York showings of Post-Impressionist and Cubist work in exhibitions by Cézanne (1911), Picasso (1911), Matisse (1912), and others. Recent critics have seized upon these two issues, contrasting Steichen's role as adventuresome impresario with an alleged artistic timidity in his personal work.[3]

As we shall see, it is an error (albeit one supported by Steichen's own writings) to link Steichen's photographs of the period 1895–1914 primarily with French Impressionism of the 1870s and 1880s. The aesthetic informing them is that of Symbolism, a movement contemporaneous with the photographs, and fully as vital and as revolutionary as the art descending from Impressionism. Placing these very beautiful prints— some of the most beautiful photographs in the history of the medium—in their proper, Symbolist context will erase the Januslike image of Steichen referred to above and will give to his early work the recognition it deserves for its contribution to the Symbolist photographic tradition that leads to our own time.

EDUARD STEICHEN WAS THE ONLY SON of Jean-Pierre and Marie Kemp Steichen, European peasants who emigrated from the tiny duchy of Luxembourg to Hancock, Michigan, in 1881, when Steichen was only eighteen months old.[4] There his sister Lillian was born in 1883. His mother became a milliner and the family's principal breadwinner after her husband's health was broken by work in the Michigan copper mines. After graduating from grammar school in 1894 Steichen began a four-year apprenticeship at the American Fine Art Company, a lithographic firm that supplied posters and display cards for the breweries, flour mills, and packinghouses of Milwaukee, a bustling city of 250,000 people and his home since 1888. While serving as apprentice Steichen also studied figure drawing with at least two local artists, Richard Lorenz[5] (1858– 1915) and Robert Schade[6] (1861–1912), in what became the Milwaukee Art Students' League.

It is difficult to pinpoint exactly, beyond practical artist's concerns, what Steichen learned in these classes. He was to write a letter of appreciation for Lorenz's instruction in 1966, almost seventy years later: "Whereas other artists also generously helped us, notably Robert Schade, it was Lorenz who gave us the real inspiration and a foundation."[7]

Steichen: *My Little Sister*. 1895.
Solio print, 1 1/2 x 1 15/16".
The Museum of Modern Art, New York.
Gift of the photographer.
Steichen's first successful photograph,
marking the beginning of his career

Indeed, the chief influence of these early teachers upon the teen-age Steichen was probably not stylistic but practical. Both artists, by virtue of the fact that they made a living as serious artists, could have encouraged Steichen to leave the commercial illustrative work he had been trained to do and to become a fine artist as well—a decision he made, over his father's objections, when he was twenty-one years old.

One of the most significant influences of these early years came to Steichen, who had begun to photograph in 1895, from a quarterly publication edited by the noted amateur photographer Alfred Stieglitz for the New York Camera Club from 1897 through 1902. This publication, *Camera Notes*, was, like its successor, *Camera Work* (1903–17), the major vehicle in America for informing serious amateurs of what was new in photography, technically and aesthetically.

By the turn of the century there had evolved, chiefly through the institution of the amateur camera club, a belief shared by American and European photographers that certain kinds of photographs could give aesthetic pleasure to those who viewed them sympathetically, and that, therefore, a certain kind of photography—often referred to as "advanced"—could be considered a valid medium of artistic expression. Among those who held this belief—Alfred Stieglitz, most notably—the criteria for judging the aesthetic worth of a photograph were borrowed in large part from the standards, the critical mechanisms, used to evaluate other works of art. It is essential to realize that of these standards, those associated with the Symbolist movement, in both its literary and its pictorial manifestations, dominated the progressive critical thought of the day.

Symbolism, flourishing at the end of the nineteenth century, could trace its origins to Rousseau and the early Romantics of the end of the eighteenth. Its qualities, according to the critic Edward Lucie-Smith, are in large measure those associated with the poets Stéphane Mallarmé and Paul Verlaine: "deliberate ambiguity; hermeticism; the feeling for the symbol as a catalyst (something which, while itself remaining unchanged, generates a reaction in the psyche); the notion that art exists alongside the real world rather than in the midst of it; and the preference for synthesis as opposed to analysis."[8]

Verlaine provided the most concise and accurate statement of its essence in his famous *Art poétique* of 1874, a poem written while he was imprisoned for shooting and wounding his lover, the poet Arthur Rimbaud. Lucie-Smith suggests that it is the manifesto of the movement:

> Car nous voulons la Nuance encor,
> Pas la Couleur, rien que la nuance!
> Oh! la nuance seule fiance
> Le rêve au rêve et la flûte au cor!

Steichen's calling card, c. 1902

For we wish for the Nuance still,
Not Colour, only the nuance!
Oh! only the nuance marries
Dream to dream, and the flute to the horn![9]

Symbolism was, above all, the art of suggestion and of synthesis.

In some measure, too, especially for the bourgeoisie, Symbolism had its negative aspects: a dandyism and snobbery and a perverse interest in the occult—a decadence which denied the validity of scientific rationalism and negated the belief in "progress" that characterized the materialism of the late nineteenth century. It was a radical, in many ways, a revolutionary stance, paradoxically insisting on the primacy of the individual's sensibility and, eventually for many Symbolists, the necessity for socialist political reform. And while it was in the strictest sense a literary movement based in France and Belgium (the playwright and essayist Maurice Maeterlinck was, as far as Steichen's history is concerned, the prime literary influence), its tenets were embraced by artists as diverse as Oscar Wilde and Richard Strauss and by art movements as far apart in time and place as the English Pre-Raphaelites and the Vienna Secessionists. Above all, the operas of Richard Wagner, with their fusion of symbolic narrative, emotionally charged music, and the plastic arts of stage design and the performing arts, represented an ideal of the Symbolist movement: the synthesis of all the arts into one.[10]

Of the critics who dealt with photography and its relationship to traditional art forms in the pages of Stieglitz's quarterlies, two seem to have influenced Steichen most and seem most important today: Charles H. Caffin (1854–1918) and Sadakichi Hartmann (1867?–1944). Caffin, an Englishman who emigrated to the United States in 1892, published the classic book on the subject, *Photography as a Fine Art*, in 1901. In it he illustrated a chapter on landscape photography with six Steichen photographs, including *The Pool—Evening*, 1899 (pl. 4). Caffin used this work to illustrate a subtle but essential point about his and Steichen's Symbolist aesthetic, namely, the Neo-Platonic idea that the ultimate "reality" a picture communicates is *suggested* by but is more than and different from its subject matter. He wrote:

Steichen's first one-man show, Milwaukee, 1900, at the home of Mrs. Arthur Robinson. Steichen Archive, The Museum of Modern Art, New York

> I set this print and some others of Mr. Steichen's alongside as many landscape pictures by other photographers (the latter what you would call handsome but very literal interpretations of nature) and invited a child of twelve, who is devoted to country life, to tell me which she liked the best. After some little while she selected this print of *The Pool*, and when I asked her why, replied: "Because it is so real." Apparently the literalness of some of the other prints had not conveyed an equal suggestion of reality.[11]

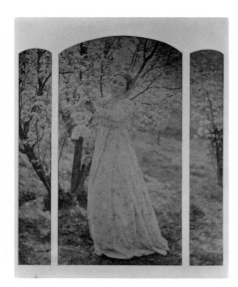

White: *Spring—A Triptych.* 1898.
Three platinum prints,
center panel, $16\frac{1}{8}$ x $8\frac{1}{8}''$;
side panels, each 15 x $2\frac{1}{8}''$.
The Museum of Modern Art, New York.
The Mrs. Douglas Auchincloss Fund

Cover of *Camera Work*, designed
by Steichen. It remained unchanged
throughout the fifty numbers issued
from 1903 to 1917

It is significant that a child was chosen to make the selection. Symbolism emphasized the intuitive over the rational and was anti-intellectual in its epistemological orientation.[12]

Caffin also recognized that Symbolism, in its opposition to the materialism that dominated the age, was religious in its aspirations. He concluded his discussion of Steichen's landscapes with these thoughts:

> For the lover of nature can never be satisfied with a mere record
> of the physical facts; to him there is, as it were, a soul within
> them, and he looks in pictures for its interpretation. It would not
> be far wrong to say that landscape art is the real religious art of
> the present age.[13]

Sadakichi Hartmann, another of Stieglitz's critics who viewed the world through Symbolist eyes, was perhaps even more important an articulator of Symbolist theories and ideas than Caffin. Hartmann, a poet and a playwright (his Symbolist drama *Christ*, 1893, caused him to be arrested in Boston) as well as a critic, had known Mallarmé and apparently taken part in his "Tuesday evenings" in the 1890s. He was responsible for introducing the Symbolist-Decadent aesthetic of the French novelist Joris-Karl Huysmans, especially his *A rebours* (Against the Grain) of 1884, into *Camera Notes* and *Camera Work*. Appropriately, it was Hartmann who introduced the first selection of Steichen photographs reproduced in *Camera Work*, in no. 2 (April 1903).

Perhaps the most influential photographer then working in the Symbolist mode was Clarence H. White (1871–1925). Steichen undoubtedly saw reproductions of White's work in *Camera Notes*, and the two men corresponded. White, after serving on the jury of the Chicago Salon of 1900, wrote to Steichen commending him on the quality of the prints he had submitted and encouraging him to visit Alfred Stieglitz when he was in New York City. This meeting took place later that year as Steichen, en route to study in Paris, introduced himself to Stieglitz and showed him a portfolio of his drawings and photographs. Stieglitz, in a gesture that became customary over the next decade, purchased three photographs for five dollars each, a sum Steichen regarded as princely. The collection of Steichen's work which Stieglitz built up and later gave to The Metropolitan Museum of Art is the largest and finest in the world.

Steichen and Stieglitz collaborated closely on two extended projects that changed the course of modern art in America: the quarterly *Camera Work* which Steichen, using the German Symbolist publication *Pan* as a model, designed, and the transformation, in 1905, of Steichen's New York portrait studio into the Little Galleries of the Photo-Secession, called "291" because of its location at 291 Fifth Avenue. There, through a

series of exhibitions organized in part by Steichen, European modernism—the work of Picasso, Braque, Brancusi, and Matisse, for example—was first shown in New York.

Steichen first lived in Paris from 1900 to 1902. Upon arrival he studied briefly at the Académie Julian, a venerable art school dominated during the preceding decade by a Symbolist group known as the Nabis, a quasi-religious fellowship of painters who worked under the influence of Paul Sérusier and, the master, Paul Gauguin. But it was a forerunner of the Nabi group, Eugène Carrière (1848–1906), a painter of mothers and children, nudes, and portraits of celebrated people, all in a misty, mono-chromatic style, who was to influence Steichen most directly. In an article published in 1901 in the British publication *The Photogram*, Steichen wrote a defense of his photographs then on view at the Royal Photo-graphic Society:

> To some of us the lower tones have more of a tendency to make beautiful than tones more brilliant, and hence the repeated use of them. One strives for harmony—harmony in color, in value, and in arrangement.
> Carrière, one of the greatest modern French painters, keeps all his pictures in a low brownish key, using no pure whites or darks; and blending his tones, he secures an ex-quisite feeling of atmosphere and shrouds that in a lovely sentiment.[14]

As can be seen from a comparison of Carrière's lithograph of Rodin (1897) and Steichen's little-known portrait of the sculptor made in 1902, Steichen's debt to the French artist is great. Similarly, Steichen's nudes with flowers and his mother-and-child pictures owe much to Carrière's Symbolist vision.

Steichen's *Rodin—Le Penseur*, 1902 (pl. 11), is a perfect example of Steichen's adoption of the Symbolist concept of synthesis: two separate negatives were combined to create the symbolic image of the master artist contemplating the works of his genius. This same concept of syn-thesis Steichen extended to the techniques and processes used to make many of his most beautiful prints. At first Steichen used commercially available platinum paper to print his negatives. Then, under the influence of the French photographer and writer Robert Demachy, whom he met in Paris, he began to experiment with the gum-bichromate process. Later, platinum prints were coated with a layer of gum bichromate, and an over-printing—in color—of the same image was applied. Sometimes three or more separate coatings of gum bichromate were layered one over the other. (See *Winter Landscape*, 1904–05, pl. 31, as an example of multiple-

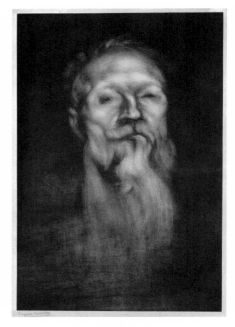

Carrière: *Auguste Rodin*. 1897. Lithograph printed in black, 20⅞ x 13¾". The Museum of Modern Art, New York. Gift of Mr. and Mrs. Carroll L. Cartwright

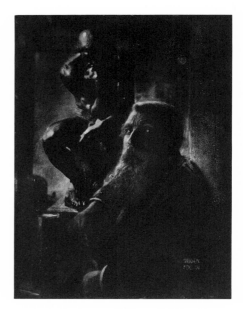

Steichen: *Rodin—Le Penseur*. 1902. Platinum and gum-bichromate print, 16½ x 12". The Museum of Modern Art, New York. Gift of the photographer

gum printing.) Technically, the work involved in making such large prints as, for example, *The Flatiron*, 1905 (pl. 56), which is gum over platinum, was enormous. In one of the few letters he wrote to Stieglitz discussing technique, the following is most revealing:

> I don't think the prints as a whole are nearly what I would like to see them—but they represent two months' hard work to say nothing of the *expense* which my bills testify to. Big plates mean more failures and cost like h—l. I wish you could see the new things— They will be hard to hang— One in particular—my pet—and [Joseph T.] Keiley [a lawyer and one of Stieglitz's closest associates] just got excited over it—one of my old Lake George things "The Big Cloud" [pl. 33] an enormous white cloud over the opposite mountain which is *inky black* making the cloud *blaze* with light as the paper is dyed brilliant greenish yellow[—]a few overhanging leaves on top— It's a whopper—and will compel attention—although I'm afraid they may refuse to hang it—d—m if they do. Another one[—]*Moonrise* [Mamaroneck, New York, 1904, pl. 35] in three printings: first printing, grey black plat[inum] —2nd, plain blue print [cyanotype] (secret)[—]3rd, greenish gum. It is so very dark I must take the glass off because it acts too much like a mirror. I hope they will handle it carefully— of course the varnish will protect it some—[15]

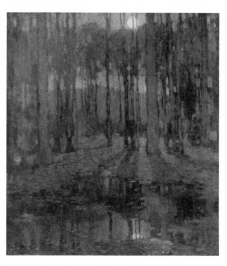

Steichen: *Night Landscape*. c. 1905.
Oil on canvas, 25 x 21″. Whitney Museum
of American Art, New York.
Gift of Mr. and Mrs. Ira Spanierman

In the creation of large, elaborately layered prints—gum bichromate over cyanotype over platinum, as in the preceding example—Steichen was the unique master. Certainly, other "advanced" photographers, Alvin Langdon Coburn, Gertrude Käsebier, F. Holland Day, Clarence White, and Frank Eugene among them, applied the ideas of the Symbolist movement to their photographic work, and many of them made very beautiful platinum or gum-bichromate prints, and, on occasion, combined the processes. But none utilized so fully the various means then available to photographers in the rich and, from a Symbolist view, appropriate way that Steichen did.

In his motifs, too, Steichen reveals his Symbolist inclinations. This early material falls into five interrelated categories: first, a small group of self-portraits, in which he projects a strong psychological need to be seen as an artist; second, the numerous landscapes, small and tremulous in the beginning, becoming increasingly expansive and resonant through the decade; third, the nudes, presented in the most Symbolist manner possible, the body merging into the lambent atmosphere that surrounds it, suggesting ineffable sorrow; fourth, portraits of two distinct types, those of men, usually artists, seen as the embodiment of genius, and those of women presented as the personification of beauty (a symbolic representa-

tion generally underscored by the inclusion of exotic flowers); finally, the fusion of the portrait of genius and the landscape, as exemplified by the very beautiful series devoted to Rodin's *Balzac*, a group that captures the essence of Steichen's art of this period.

It is interesting to note that the paintings Steichen made at this time (for, particularly after his return to France in 1906, Steichen was *primarily* a painter) employ virtually the same limited motifs as the photographs. Indeed, on numerous occasions, works in both mediums were exhibited together.

Thus, through the merging of Symbolist motifs and techniques, these early photographs embody the ultimate expression of the Symbolist aesthetic in American photography in the first decade of this century. But, perhaps because of their technical synthesis, these works presented problems for the critics of the day. One writer, when confronted with the fact that these prints did not look like photographs, resolved the issue by suggesting that "*they* are photographs; *they* were drawn by light. But it is the ordinary every-day photographs which are not photographs, and should properly be called cameragraphs or machinographs."[16] And, as Steichen himself suggested in the letter just quoted, they were very difficult and time-consuming to make. Thus, although new finds of original Steichen prints turn up from time to time, the number of great works is extremely, almost unnaturally, small, fewer even than one hundred works, and a significant portion of these images exist in only a unique print.

Steichen made few of the kind of prints we have discussed after 1914, when World War I forced him, his wife, and two daughters to return to the United States from France, where they had lived since 1906. When first published these photographs had great importance. Because they were made—to quote Stieglitz—by "a 'real artist,'" they were proof that photographs could be works of art.[17] Stieglitz reproduced seventy-four plates of Steichen's works, far more than he devoted to the work of any other photographer, in numerous issues and two special supplements of *Camera Work*. Because of the advanced Symbolist aesthetic that informs them, they presented a vital counter to the cliché-ridden genre photographs that were (and still are) the concern of the camera clubs. They were, in short, what a very significant portion of modern art was all about.

These works can be seen as forerunners of a kind of photography very much in vogue today. The mysterious narrative sequences photographed by Duane Michals, for example, project ideas akin to those in the Symbolist etchings of Max Klinger (1857–1920). The strange masked creatures in the images of the late Ralph Eugene Meatyard correspond dramatically to the grotesques inhabiting the tortured paintings of James

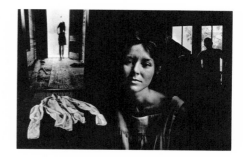

Uelsmann: *Room #1*. 1963. Silver print, 11 x 14″. Collection the photographer

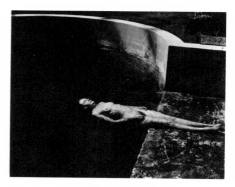

Weston: *Nude Floating*. 1939.
Silver print, 7¹/₂ x 9¹/₂″.
The Museum of Modern Art, New York.
Gift of Edward Steichen

Samaras: *Photo-Transformation*. 1976.
Polaroid print, 3 x 3″.
The Museum of Modern Art, New York.
Gift of the American Art Foundation

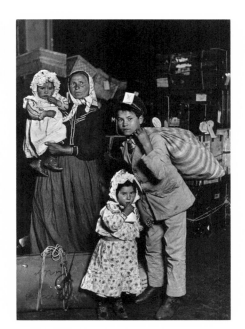

Hine: *Italian Family Seeking Lost Baggage, Ellis Island.* 1905. Silver print, $5^1/_2$ x $4^1/_2$". The Museum of Modern Art, New York. Purchase

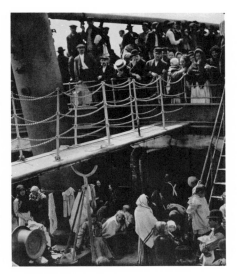

Stieglitz: *The Steerage.* 1907. Photogravure, $7^3/_4$ x $6^1/_2$". The Museum of Modern Art, New York. Gift of Alfred Stieglitz

Ensor (1860–1949). Symbolism is at the very heart of the synthetic photographs of Jerry Uelsmann, and it even appears in the work of the master, Edward Weston, chiefly in the strange works from just before and during the war years. The boldest, most brilliant exponent of the Symbolist tradition working today is Lucas Samaras, whose obsessive Polaroid self-portraits form a virtual catalog of Symbolist ideas; the hermeticism, obsession with self, and synthesis of the late nineteenth century are translated into the late twentieth. (The self-portraits relate in a fascinating way to the work of F. Holland Day, mentioned at the beginning of this essay.) The vitality of the Symbolist aesthetic is astounding, and in any future account of it the role played by Steichen's Symbolist photographs must be recognized.

ONE ADDITIONAL QUESTION REMAINS to be discussed, one that shifts the focus for the moment from Steichen to Stieglitz: How did the Symbolist aesthetic influence Stieglitz's work?

On a technical level, the kind of hybrid, bravura print that Steichen had mastered had little influence on Stieglitz, whose only deviation from straight platinum or gum-bichromate prints (or their pellucid translation into hand-pulled gravure) was a few experimental glycerin prints made around 1900. Also, Stieglitz's subject matter—street views in New York and Paris or portraits of individuals, not generalized types—was always too particularized, too obviously related to life in the real world, to embody the Symbolist formula that placed art parallel to yet separate from the world we live in. While Stieglitz and the documentarian Lewis W. Hine, for example, differ in many respects, they both dealt with various aspects of the same reality. A similar analogy could not be made with Steichen.

Yet, to be a student in Berlin in the late 1880s, as Stieglitz was, was to be enveloped in an atmosphere thick with the elements of Symbolism.[18] The effects of this aesthetic education are everywhere apparent. Arnold Böcklin (1827–1901), for example, a painter of mystical, allegorical subjects, was Stieglitz's favorite painter at the turn of the century; his *Isle of the Dead* (1880) hung in reproduction in Stieglitz's New York apartment.[19] Similarly, the first exhibition of nonphotographic art held at "291" presented the drawings of Pamela Colman Smith (1878–?), a mysterious, American-born artist living in London, best known for her designs for the ultimate Symbolist occult object, the Rider deck of tarot cards.[20] Gertrude Stein, the Symbolist roots of whose work were stressed by Edmund Wilson,[21] was published for the first time anywhere in *Camera Work*, a publication, as noted earlier, that was modeled upon *Pan* (Berlin), but also upon other European Symbolist periodicals.

In his own photographs, as some of their titles suggest—from *Sunlight and Shadow, Paula, Berlin* (1889) through *The Hand of Man* (1902) to *Spiritual America* (1923)—there are recurrent Symbolist themes. Perhaps Stieglitz's most beautiful, if elusive, pictures are the series of photographs he called the *Equivalents*. These were shown at the Anderson Galleries in 1924 in the exhibition "Songs of the Sky—Secrets of the Skies as Revealed by My Camera."[22] This evocation of music is quintessentially Symbolist. He said:

> I wanted a series of photographs which when seen by Ernest Bloch (the great composer) he could exclaim: Music! music! Man, why that is music! How did you ever do that? And he would point to violins, and flutes, and oboes, and brass, full of enthusiasm, and would say he'd have to write a symphony called "Clouds." Not like Debussy's but *much, much more.*
> And when finally I had my series of ten photographs printed, and Bloch saw them—what I said I wanted to happen happened *verbatim.*[23]

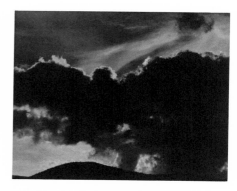

Stieglitz: *Equivalent.* 1926.
Silver print, $3^5/_8$ x $4^1/_2$".
The Museum of Modern Art, New York.
Gift of Mrs. Dorothy S. Norman

The *Equivalents* are the culmination of an involvement in Symbolist thought extending back into Stieglitz's youth.

It is obvious, then, why Steichen's Symbolist photographs, during the period under discussion, were so admired, published, exhibited, and purchased by Stieglitz. He inscribed a copy of a double issue of *Camera Work* (no. 42–43), devoted entirely to Steichen's work, as follows:

> Dear Steichen: This is the first copy of the "Steichen Number." It is just out. It happens to be the Night before Thanksgiving. Nothing I have ever done has given me quite as much satisfaction as finally sending this Number out into the world. Real friendship is rarer than real art— That is, heaven knows, rare enough these days.
>
> "291"
> November 26—1913[24]

Yet, with the advent of World War I, the close association between Steichen and Stieglitz ended. Undoubtedly there were many reasons, but most important perhaps were the affiliations each had to the countries tragically at war: Stieglitz, the son of German émigrés, himself educated in Germany, was neutral if not pro-German; Steichen, after twelve years in residence, was devoted to France.

The war seemingly changed everything. Steichen, who enlisted in the United States Army in 1917, learned to make sharply defined photographs from vibrating biplanes high above enemy territory. The experience, he declared in his autobiography, clarified his vision and taught him

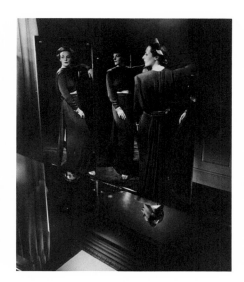

Steichen: Fashion photograph for *Vogue*,
Nov. 1, 1935. Copyright © 1935 (renewed)
1963 by The Condé Nast Publications Inc.

Installation of Steichen photographs
at the first exhibition at "291,"
November 24, 1905 – January 5, 1906

to appreciate the beauty of the unmanipulated photograph. In 1923 he ceased his career as a painter, and in a spectacular bonfire in the garden of his country home in Voulangis, France, he burned all his paintings in his possession. In the same year his marriage of twenty years ended in divorce. Employed by Condé Nast, publisher of *Vogue* and *Vanity Fair*, Steichen then became the highest-paid fashion photographer in the world. With its crisp sparkle, his commercial work, designed as it was to attract the eye to the printed page, suggests that Steichen had renounced his Symbolist aesthetic along with his career in painting. Essentially, however, Steichen remained a Symbolist throughout his long life, in his fashion work and in later projects as well.

The famous exhibition he directed for The Museum of Modern Art in New York, "The Family of Man" (1955), for example, was an enormous synthesis of the work of hundreds of photographers, and it was rife with dilute Symbolist ideas. The final work of his great old age (he died in 1973 two days short of his ninety-fourth birthday) was a color motion picture, unfortunately left incomplete, of a small shadblow tree on his Connecticut estate. *The Little Tree* was to have symbolized, through the shadblow's determined struggle to exist through all adversity, the very nature of existence itself.

The works of his youth reproduced here seem at once simpler and more successful than the grandiose projects of later life. Emphatically unphotographic and on occasion showing the seams that hold them together, the early images are nevertheless among the masterworks of photography. They still stir the sense of marvel that Roland Rood experienced when he first saw a number of them at the inaugural exhibition of "291": "And Steichen's works in the little show are certainly wonderful. I have never seen a more beautiful wall of black and white than he covers. I went back twice to see if they were, in truth, as they had appeared to me at that first night. And they were! They haunt me to this day as a strange and lovely dream."[25]

1. Robert Demachy, "Exhibition of the New American School of Artistic Photography at the Paris Photo-Club," *The Amateur Photographer* (London), vol. 33, April 1901, p. 275. An earlier, slightly smaller version of this show opened at the Royal Photographic Society, London, in 1900.

2. Edward Steichen, *A Life in Photography* (Garden City, N.Y.: Doubleday & Co. in collaboration with The Museum of Modern Art, 1963), unpaged (chap. 2).

3. Henry Geldzahler, for example, at the time of Steichen's retrospective exhibition at The Museum of Modern Art, New York, in 1961, declared: "Thus we get a dual picture of Steichen's role in the early years of this century. The photographer dedicated to pictorial photography—the translation of Impressionist, etc., painting into photographs, an aesthetic dominated by what would seem in retrospect to be a frankly reactionary reverence for the dreamy-misty. And Steichen the unshockable, quickly acclimated eye, eager for New York to share the powerful new formal freedom that so outraged his contemporaries. Both seem important, but if the Photo-Secession laid the ground for the Armory Show (which it did) and if the Armory Show vibrations have never died down (which they haven't) then we must be more grateful to Steichen the messenger than to Steichen the pictorial photographer. But this too may change." ("Edward Steichen: The Influence of a Camera," *Art News* [New York], vol. 60, no. 3 [May 1961], p. 53.)

4. Steichen was christened simply Eduard Steichen. Very early in his life he seems to have adopted his father's name, Jean-Pierre, as a middle name, and he used "Eduard J. Steichen" throughout this early period when writing for publication. Occasional references to him in French periodicals employed the French "Edouard," just as occasional English and American texts spelled it "Edward." Legally, as for example on his naturalization papers, signed in 1900, he used "Edward J. Steichen." He used this name exclusively from sometime during World War I until his death.

5. Lorenz (whom Steichen called "Lorence" in his autobiography) was born in Weimar, Germany, where he studied at the Royal Academy on a scholarship endowed by Franz Liszt. In 1886 he came to Milwaukee, where he worked on what now seems a peculiarly exotic project: painting only the horses (other imported German artists dealt with the trees, mountains, and sky) in enormous panoramic views which depicted on canvases 25 feet high and 350 feet long scenes like the Battle of Gettysburg or a Voyage down the Mississippi. These panoramas, the precursors of the newsreel, the travelogue, and the documentary film, were usually unrolled before paying audiences as educational entertainment. (For a discussion of this phenomenon see H. Stuart Leonard et al., *Mississippi Panorama* [catalog], St. Louis City Art Museum, 1949, pp. 127–37; also, Porter Butts, *Art in Wisconsin: The Art Experience of the Middle West Frontier* [Madison: Madison Art Association, 1933], especially chap. 4, "Panorama Scene Painting," pp. 51–65.)

Traveling to San Francisco in 1887, Lorenz became entranced with the American West. By the time of his death of a mysterious and painful degenerative disease at the age of fifty-seven, he was, with the exception of Frederic Remington, the nation's foremost painter of cowboys, Indians, and their soon-to-vanish world.

6. Schade was born in New York City. In 1863 his parents, emigrants from Prussia, moved to Milwaukee, where Schade studied at the school of the Art Association with the painters Bridge Tradsham, Heinrich Vianden, Henry and Julius Gugler, and the photographer Edward Kurtz. (I am indebted to Robert G. Carroon, Curator of Research, Milwaukee County Historical Society, for this information, taken from his letter to me dated June 27, 1977.) In 1878 Schade went to Munich, where he studied for three and a half years, principally under a painter of historical subjects, Alexander Wagner (1838–1919). In the 1880s Schade joined the panorama painters along with Lorenz, began to teach privately, and made two additional trips to Munich for study with Wagner. The final twenty years of his life, aside from a brief sojourn in New Mexico, were spent in Milwaukee, where he made his living primarily as a portrait painter.

7. Letter from Steichen to Miss Margaret Fish dated April 8, 1966. See Margaret Fish, *An Exhibition in Tribute to Richard Lorenz, 1858–1915* (catalog), Milwaukee Art Center, 1966, p. 5.

8. Edward Lucie-Smith, *Symbolist Art* (London: Thames and Hudson, 1972), p. 55.

9. Ibid., p. 58.

10. Because relating Pictorial Photography to Symbolism is an unfamiliar approach, it seemed to me essential to describe the outstanding characteristics of the Symbolist movement—even in the face of the oversimplification that is inevitable in a brief essay.

11. Charles H. Caffin, *Photography as a Fine Art* (1901, reprint ed., Hastings-on-Hudson, N.Y.: Morgan & Morgan, 1971), p. 160.

12. Maurice Maeterlinck's *The Intelligence of the Flowers* is a case in point.

13. Caffin, op. cit., p. 166.

14. Eduard J. Steichen, "The American School," *The Photogram* (London), vol. 8, no. 85 (January 1901), p. 9.

15. Leaf 54, Alfred Stieglitz Archive, Collection of American Literature, The Beinecke Rare Book and Manuscript Library, Yale University, New Haven, Conn.

16. Roland Rood, *Camera Work*, no. 14 (April 1906), p. 37.

17. Alfred Stieglitz, "Eduard J. Steichen's Success in Paris," *Camera Notes*, vol. 5, no. 1 (July 1901), p. 57.

18. A vivid self-portrait of Stieglitz during this period is evoked in Dorothy Norman, *Alfred Stieglitz: An American Seer* (New York: Random House, 1973), pp. 24–35.

19. William Innes Homer, *Alfred Stieglitz and the American Avant-Garde* (Boston: New York Graphic Society, 1977), p. 69.

20. Ibid., p. 237, note 27.

21. Edmund Wilson, *Axel's Castle* (New York: Charles Scribner's Sons, 1931), pp. 243–44.

22. Norman, op. cit., p. 144.

23. Ibid., pp. 143–44.

24. Photostat of an inscribed page of *Camera Work* in a box marked "Memorabilia," Steichen Archive, The Museum of Modern Art, New York.

25. Roland Rood, review in the January 1906 issue of *The American Amateur Photographer*, reprinted in *Camera Work*, no. 14 (April 1906), p. 37.

PLATES

1. SELF-PORTRAIT. MILWAUKEE. 1898

Steichen was nineteen when he made this self-conscious photo-
graph of himself, the empty picture frame carefully echoing the
black border around the print. Exhibited in F. Holland Day's
"New American School" exhibition in London in 1900, this work
provoked one unknown critic to write: *Imagine half a young man
clothed only in shirt and trousers, standing before a light wall,
quite bare, save for a black picture frame that he could easily
swallow at a gulp, and you have a self-portrait. It is probable that
his missing half is at his next door neighbour's, for we notice that
his address is 342$^1/_2$ Seventh Street, Milwaukee.*

Photography (London), vol. 12, October 4, 1900, p. 654.

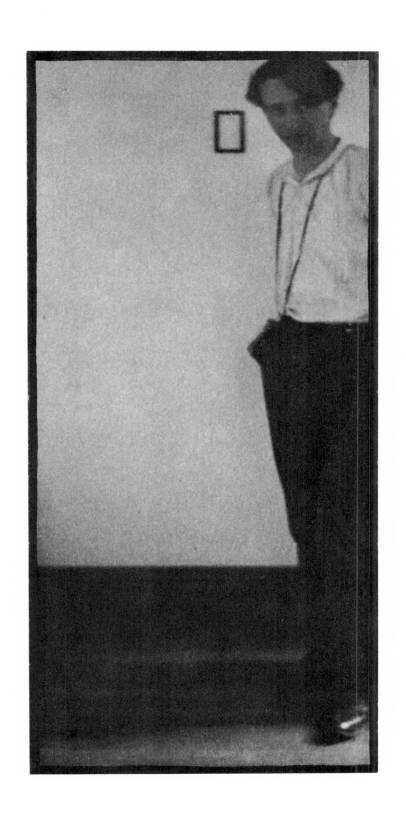

2. Lady in the Doorway. Milwaukee. 1898

This work and the one preceding were the first Steichen prints to be placed on exhibition. In 1899 he sent them to the Second Philadelphia Photographic Salon: *The prints were accepted and hung by the jury. I never heard of any bells being rung for them, but I did receive a letter from Clarence White [one of the jurors], saying that my two pictures showed originality—"a quality which needs to be encouraged."*

Edward Steichen, *A Life in Photography* (Garden City, N.Y.: Doubleday & Co., 1963), unpaged (Chapter 1).

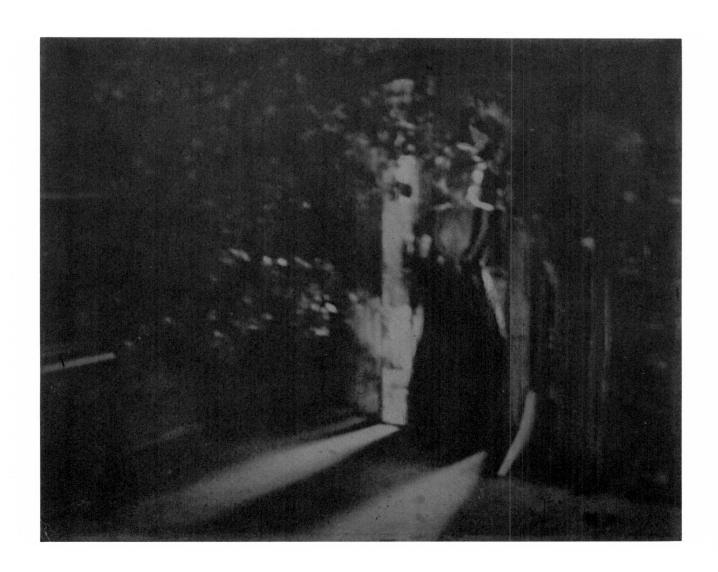

3. WOODS—TWILIGHT. 1898

We occasionally find ourselves in darker parts of the world, and, as a rule, feel more easy there. What a beautiful hour of the day is that of the twilight when things disappear and seem to melt into each other, and a great beautiful feeling of peace overshadows all. Why not, if we feel this, have this feeling reflect itself in our work? Many of the negatives have been made at this hour, many early in the morning or on dark grey days.

Eduard J. Steichen, "The American School," *The Photogram* (London), vol. 8, no. 85 (January 1901), p. 6.

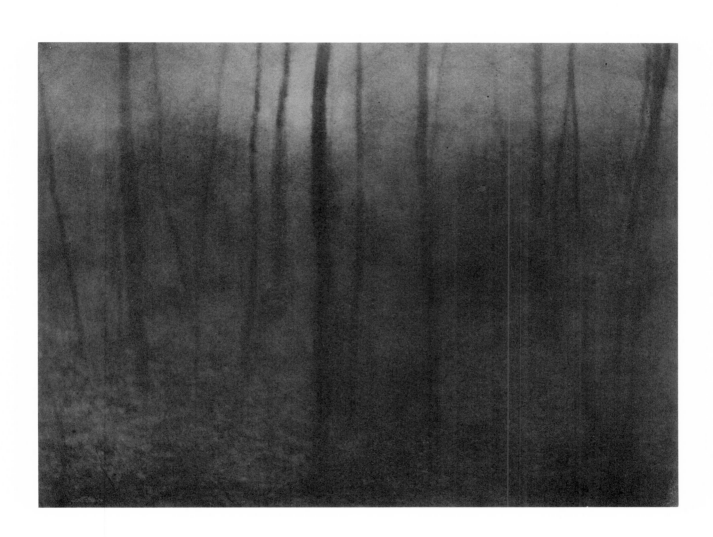

4. THE POOL—EVENING. MILWAUKEE. 1899

Then Whistler, whose influence few if any moderns have escaped . . . affected this young man profoundly. He found in the great artist not only technical example but a kinship of spirit. Steichen himself is somewhat arrogantly intolerant of the commonplace; rapturously devout toward that which is choicely beautiful; but, first and foremost, he was keenly sensitive to the master's abstraction of spirit, to his preference for the expression of the idea. So Steichen sought it where for a while, in the seventies, Whistler sought it, and where we ordinary folk who are not painters seek for it, especially when we are young, namely, in the twilight and the night. It is in the penumbra, between the clear visibility of things and their total extinction in darkness, when the concreteness of appearances becomes merged in half-realized, half-baffled vision, that spirit seems to disengage itself from matter and to envelope it with a mystery of soul-suggestion.

Charles H. Caffin, "The Art of Eduard J. Steichen," *Camera Work* (New York), no. 30 (April 1910), p. 34.

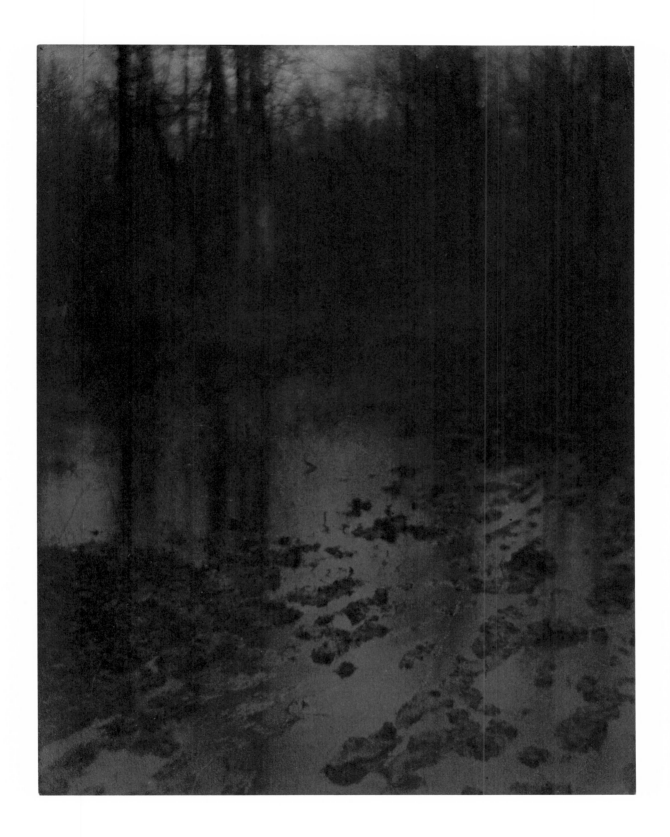

5. Woods in Rain. Milwaukee. 1898

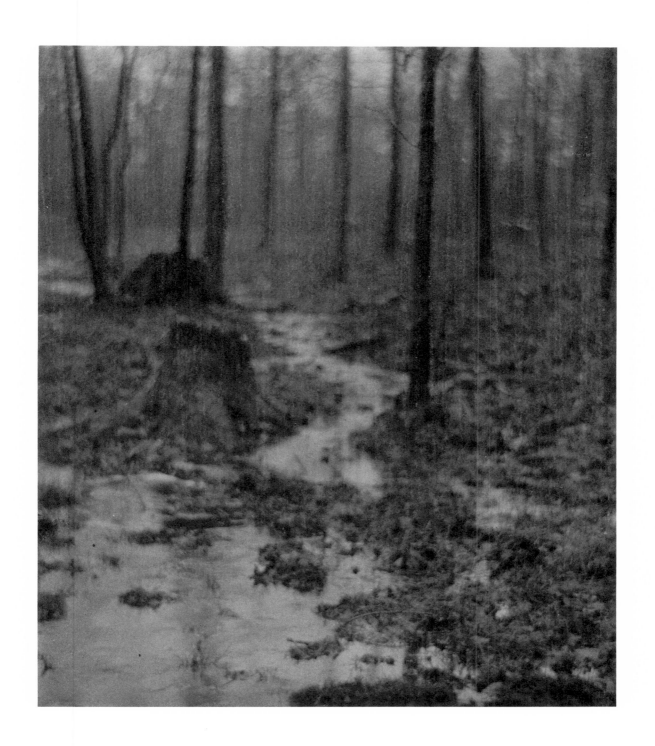

6. WOOD LOT—FALLEN LEAVES. 1898

7. Farmer's Wood Lot. Milwaukee. 1898

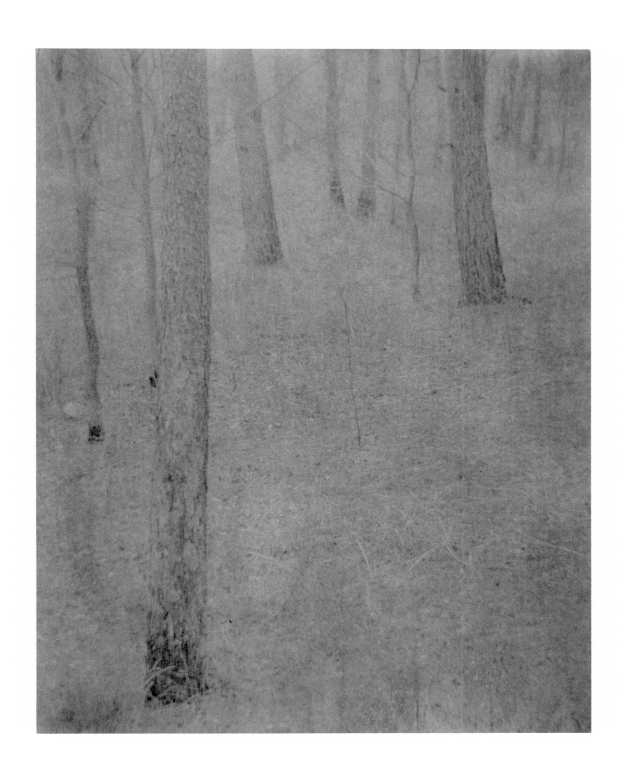

During his first trip to Europe, Steichen visited Rome. He wrote to his friend and fellow portrait photographer Gertrude Käsebier in 1902:

Roma—MDCCCCII
 There are trees in the Villa de Medicis that are so full of sap and growth that they have put great iron bands around them to keep them from bursting—I feel that way myself!

Leaf 28, Steichen Correspondence, Alfred Stieglitz Archive, Collection of American Literature, The Beinecke Rare Book and Manuscript Library, Yale University, New Haven, Conn. Hereafter referred to as Beinecke.

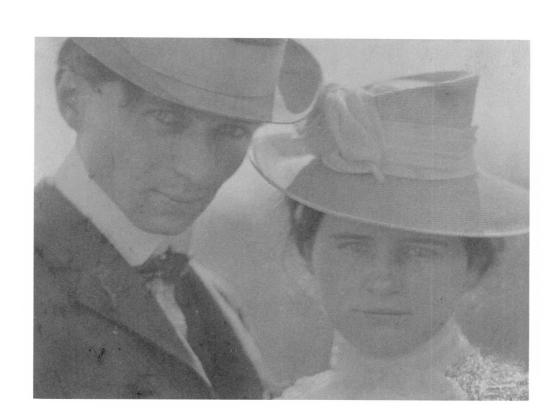

9. BARTHOLOMÉ. 1901

Steichen photographed the French sculptor Paul-Albert Bartholomé (1848–1928) before his most celebrated work, *Le Monument aux morts*, 1895, in Père Lachaise cemetery, Paris. Bartholomé wrote: *I am irritated by most of the photographs in which the authors have intervened to create works that are no longer photographs and are not drawings. They suggest to me only imperfect imitations of etchings or of reproductions of paintings. . . . I do not mean to say that one cannot produce fine works with photography, but one should stick to composition, to selection, to the variety of lightings, to his own preferences in arrangement, and I assure you, that if he lets it go at that, then gradually the machine and the light will give him results entirely personal. Think, compose, prepare your subject in all possible ways, use feeling, then open the objective [lens] and put your hands in your pockets, or else have someone put handcuffs on you.*

Quoted by George Besson, in "Pictorial Photography: A Series of Interviews," *Camera Work* (New York), no. 24 (October 1908), pp. 18–19.

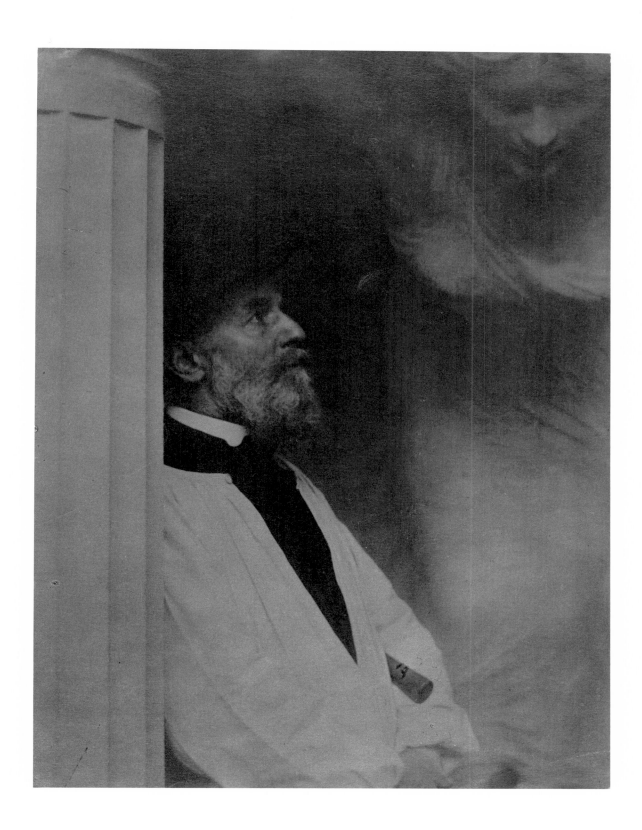

10. EDMOND JOSEPH CHARLES MEUNIER. PARIS. 1907

Very little is known about this French artist, except that he was born at an unknown time in the nineteenth century in Colombes, was the student of Eugène Meunier (his father?), and exhibited in the Paris Salons of 1874 and 1878. Steichen has photographed him before what we can presume to be one of his sculptures, just as he posed Matisse, Rodin, and Bartholomé in front of theirs.

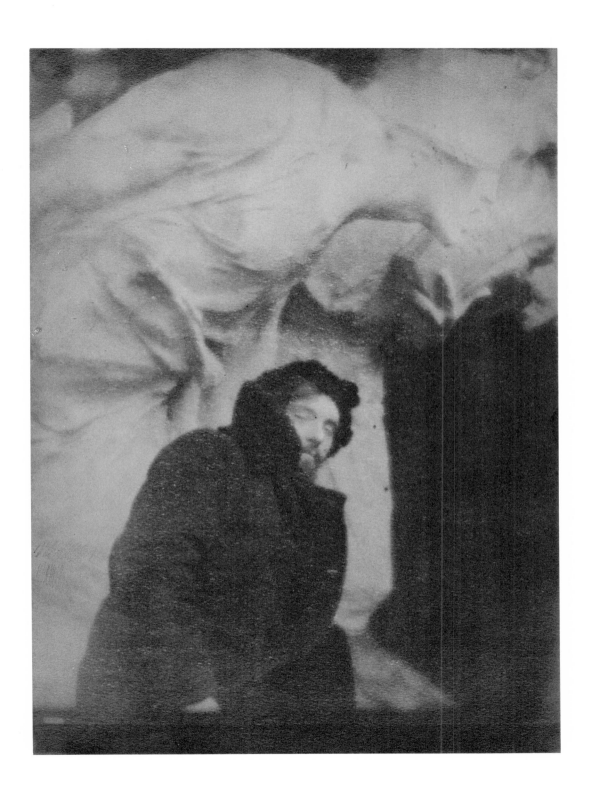

11. RODIN—LE PENSEUR. 1902

Steichen wrote the following letter to Stieglitz from Paris, probably in 1901: *I wish you could hear some of the fine things the big painters & artists here have to say when I can show something good. . . . I could cite dozens of things—up to Rodin himself—who took my hand in big silence the first time he went through my portfolio—At another time when I had the honor to dine with him at his home—he said of one of the things that it was a remarkable photograph and a remarkable work of art—a chef d'oeuvre—as he would have it (a very recent print—a self portrait in Gum Bichromate [pl. 13]). Ah well I am excited and saying too much—please do not think it is vanity Mr. Stieglitz—I assure it is not—merely patriotism to photography—. . . I only wish I could give it more time—even now I fear I am giving it too much.*

Leaf 3, Beinecke.

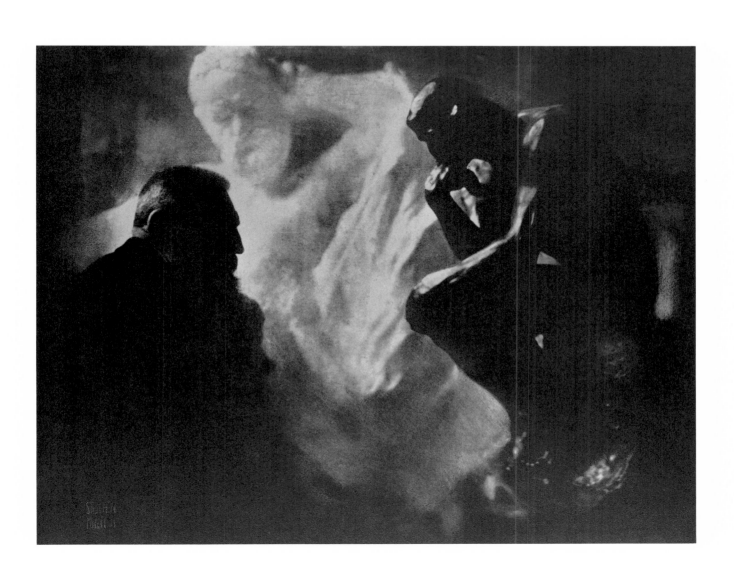

12. ALPHONSE-MARIE MUCHA. PARIS. 1902

Steichen photographed the Czech artist Alphonse-Marie Mucha
(1860–1939) standing before his famous poster of Sarah Bernhardt
in *La Dame aux Camélias*: *I cannot take more than one photo-
graph in a day. It means the complete merging of myself in the
personality of my subject, a complete loss of my own identity, and
when it is over, I am in a state of collapse, almost. The commercial
photographer, with his forty sittings a day, cannot of course enter
into the individuality of his sitter as I do.*

*Of course photography is only a side issue with me—I am a
painter, first, last, and all the time. But there are certain things that
can be done by photography that cannot be accomplished by any
other medium, a wide range of finest tones that cannot be reached
in painting.*

Steichen, quoted in an unidentified Milwaukee newspaper, dated
August 30, 1902. From a scrapbook assembled by Steichen's
mother, The Steichen Archive, The Museum of Modern Art, New
York.

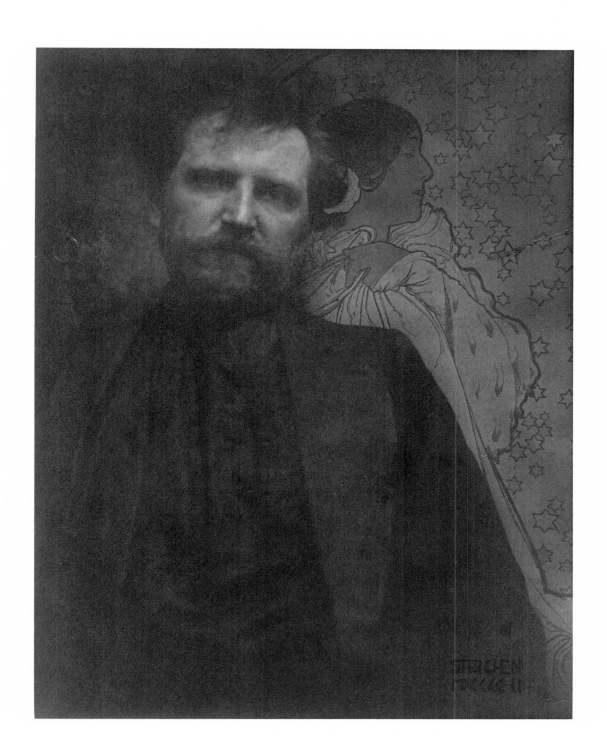

13. SELF-PORTRAIT WITH BRUSH AND PALETTE. PARIS. 1902 (negative 1901)

In the "Self-Portrait," one notices at once the forehead and large nose with their attendant nobility of character, and other features betraying the capability of the original for great things. The position of the hand, with long fingers, grasping a brush, shows great flexibility of purpose and work, a power which is accentuated by the subtle curve as though the brush had been used. All other details of dress and surroundings are suppressed, and we see Mr. Steichen only as artist, genius, and leader.

Anonymous, "Mr. Steichen's Pictures," *The Photographic Art Journal* (London), vol. 2, no. 14 (April 15, 1902), pp. 27–28.

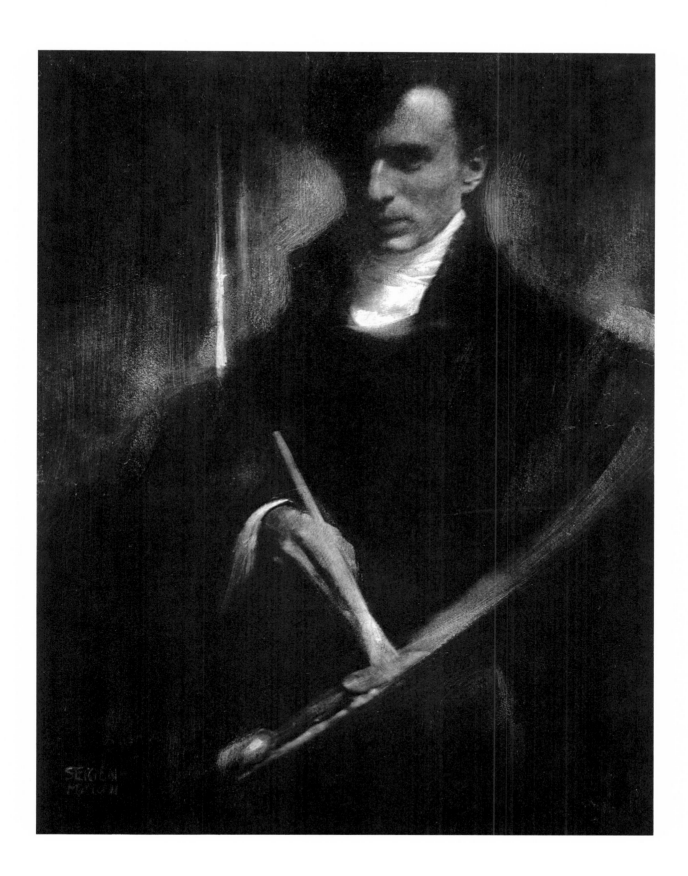

14. GEORGE FREDERIC WATTS. 1901

The British artist George Frederic Watts (1817–1904) painted a great many portraits of celebrated Victorian artists, scholars, and politicians, adding each to what he called his "Hall of Fame." Upon his return to America, Steichen similarly described his own portraits when interviewed for a Milwaukee newspaper: *Full of enthusiasm, and in a naive and delightful state of satisfaction with the world and his art, Edward J. Steichen has returned to Milwaukee for a brief sojourn before he opens his studio in New York. . . .*

Young Steichen, who was the first to raise photography to an artistic plane sufficiently elevated to receive a place in the Paris salon, talked interestingly and enthusiastically about his work this morning. . . . "My 'Great Men' series includes portraits of Rodin, Maeterlinck, George Frederick Watts, the eminent English artist, Zengwill, Lenbach, the great German portrait artist, Besnard, who is perhaps the greatest living exponent of the modern school of art, William M. Chase of New York, Mucha, the painter and many others. Then too, I have hosts of pictures of young men, who I expect will be great. . . ."

Clipping dated August 30, 1902, Steichen scrapbook, The Steichen Archive, The Museum of Modern Art, New York

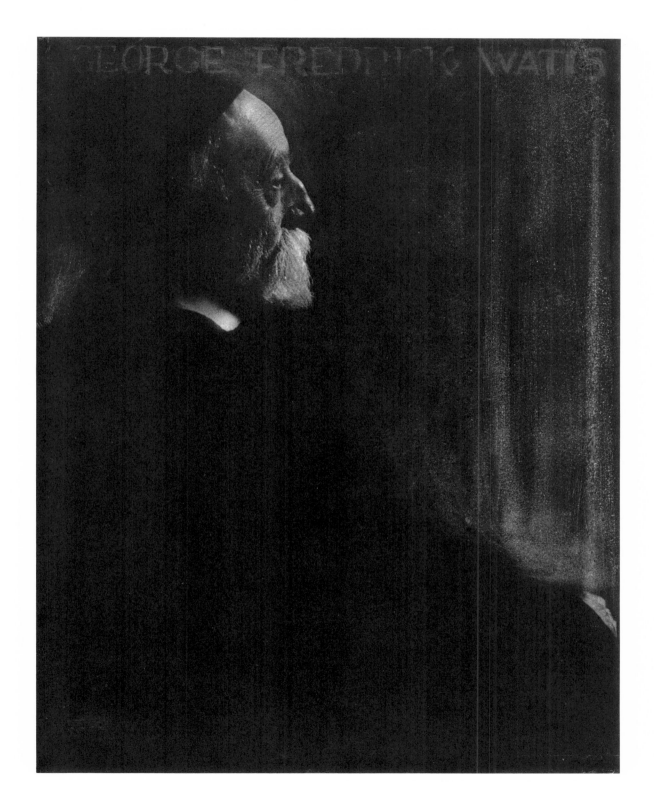

15. FREDERICK H. EVANS. 1900

Originally a bookseller by trade, Frederick H. Evans (1853–1943) made a celebrated photographic study of English and French cathedrals, printing the work in the richest of platinum prints. The photograph Evans is studying here is by F. Holland Day, who has posed himself as Christ. Steichen helped Day install the "New School of American Photography" exhibition in the Royal Photographic Society, London, in the fall of 1900, the probable date of this photograph.

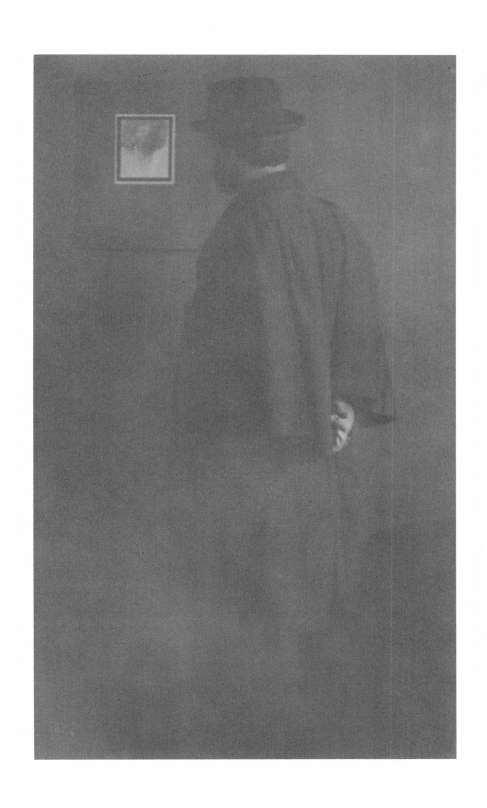

16. The Black Vase. 1901

From an unidentified newspaper clipping, dated August 7, 1902, in the album assembled by Steichen's mother: *Edward J. Steichen of Milwaukee and New York, portrait painter and photographer, arrived on the* Pennsylvania *from Hamburg. His photograph, "The Black Vase," which he exhibited in the Brussels Photographic Salon, was purchased by the Belgian government, which ordered it hung in the National Gallery at Brussels.*

The hanging of a photograph in a gallery with paintings brought loud protests from artists. It is the first time a photograph had been officially recognized as worthy of a place in a national collection.

Steichen scrapbook, The Steichen Archive, The Museum of Modern Art, New York. A recent survey of various Belgian public collections failed to uncover the whereabouts of this work.

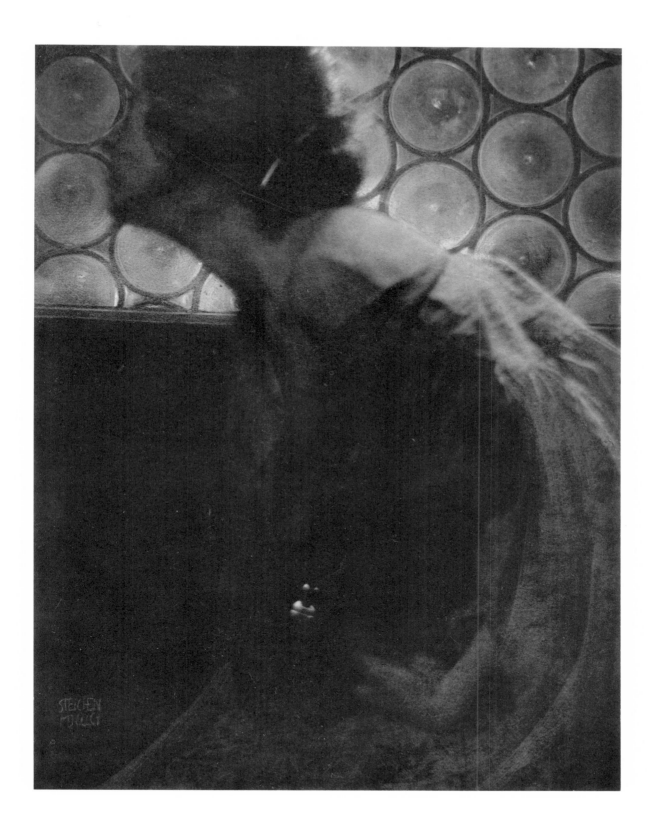

17. THE MIRROR. 1901

From the *New York Herald*, Paris edition, December 27, 1900:

CHRISTMAS DINNERS

Artistic Gathering at Mr. Edward J. Steichen's Studio in the Latin Quarter.

A Christmas dinner was given by Mr. Edward J. Steichen, in his studio at 83 boulevard Montparnasse, in honor of the arrival of his confrere, Mr. F. Holland Day, of Boston. Covers were laid for six, the other four being: Mr. Frank Eugene, of New York; Mrs. William E Russell and Miss Mary Devins, of Cambridge, and Mrs. Elise Pumpelly Cabot, of Boston, who, with Mr. Steichen and Mr. Day are the representatives of the new school of American artist-photographers happening at the present moment to be on this side of the Atlantic. The studio was lighted with the red glow of silk lanterns, which Mr. Steichen was fortunate enough to obtain from a Japanese Government official at the Exhibition, and was decked with holly and mistletoe.

Toasts were drunk in honor of the newly-elected American members of the "Linked Ring," Mrs. Gertrude Käsebier, of New York, being the first woman to be elected to this body. Before breaking up the banquet, a curiously improvised medley of the "Marseillaise," "God Save the Queen" and "America" was sung, and toasts were drunk to Her Majesty and the French and American Presidents.

Steichen scrapbook, The Steichen Archive, The Museum of Modern Art, New York.

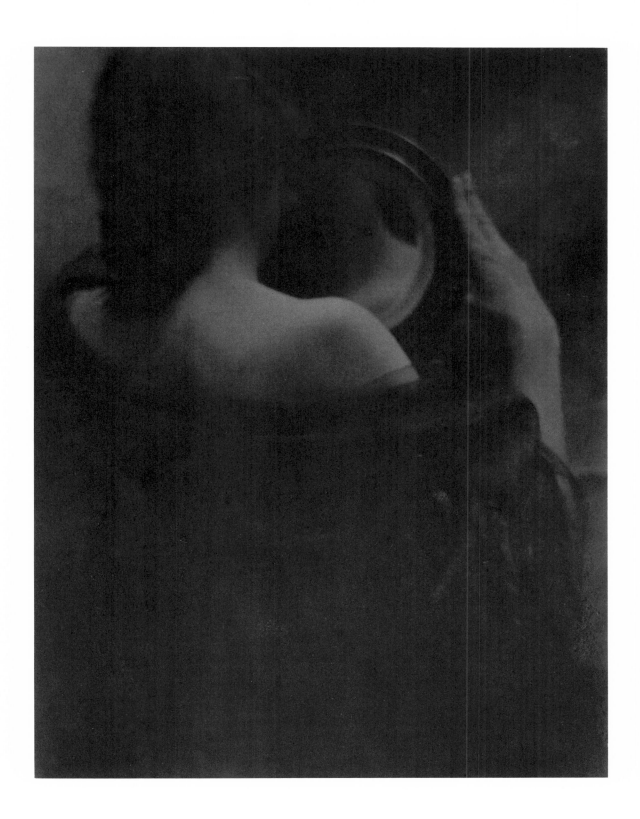

18. The Cat. 1902

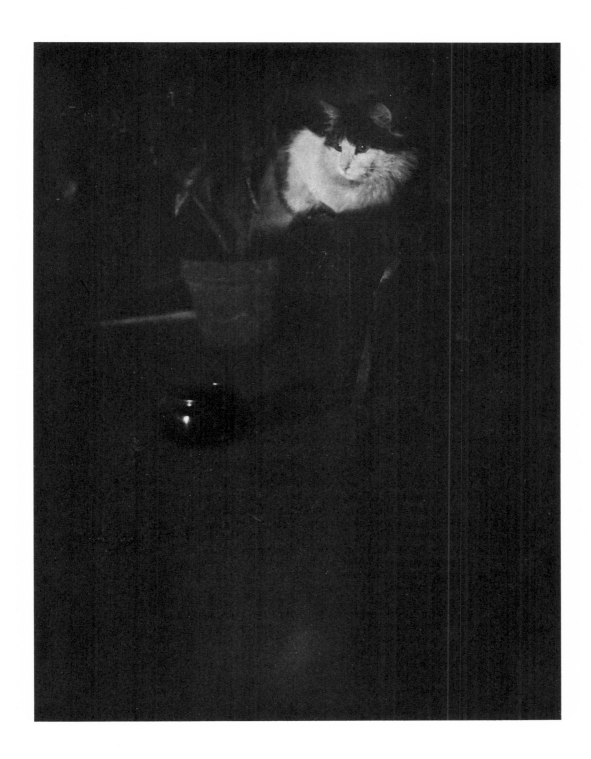

19. LA CIGALE. 1907 (negative 1901)

Steichen's photographic nudes are not as perfect as the majority of his portraits, but they contain perhaps the best and noblest aspirations of his artistic nature. They are absolutely incomprehensible to the crowd.

To him the naked body, as to any true lover of the nude, contains the ideals, both of mysticism and beauty. Their bodies are no paeans of the flesh nor do they proclaim absolutely the purity of nudity. Steichen's nudes are a strange procession of female forms, naïve, non-moral, almost sexless, with shy, furtive movements, groping with their arms mysteriously into the air or assuming attitudes commonplace enough, but imbued with some mystic meaning, with the light concentrated upon their thighs, their arms, or the back, while the rest of the body is drowned in darkness.

"What does all this mean?" Futile question. Can you explain the melancholy beauty of the falling rain, or tell why the slushy pavements, reflecting the glaring lights of Fifth Avenue stores, remind us of the golden dreams the poets dream?

Sidney Allan [Sadakichi Hartmann], "A Visit to Steichen's Studio," *Camera Work* (New York), no. 2 (April 1903), p. 28.

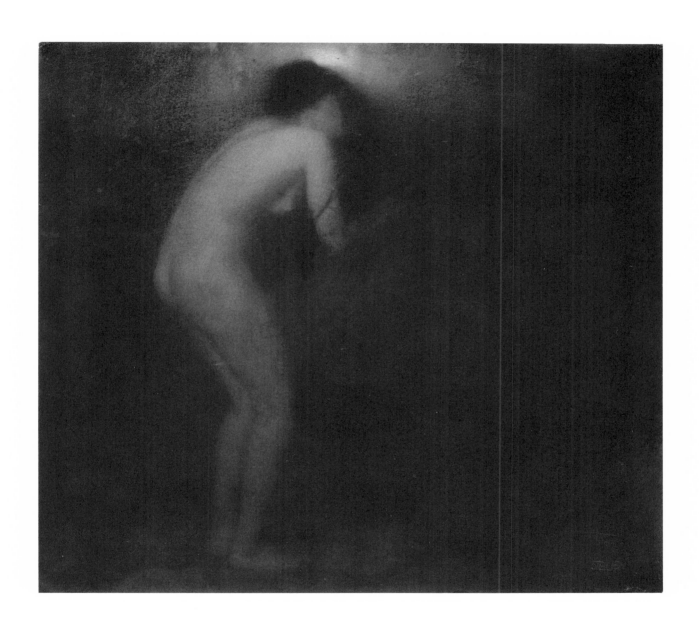

20. Figure with Iris. 1902

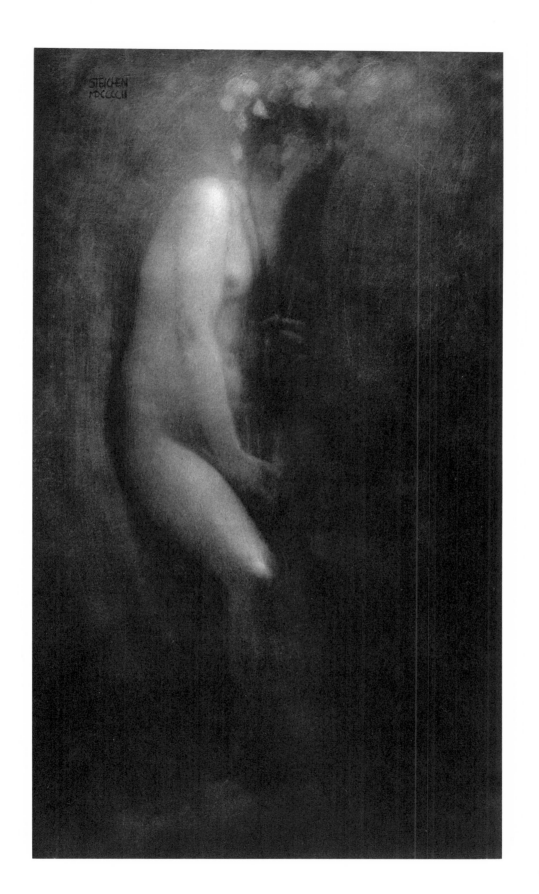

21. LITTLE ROUND MIRROR. PARIS.
1902 (negative 1901)

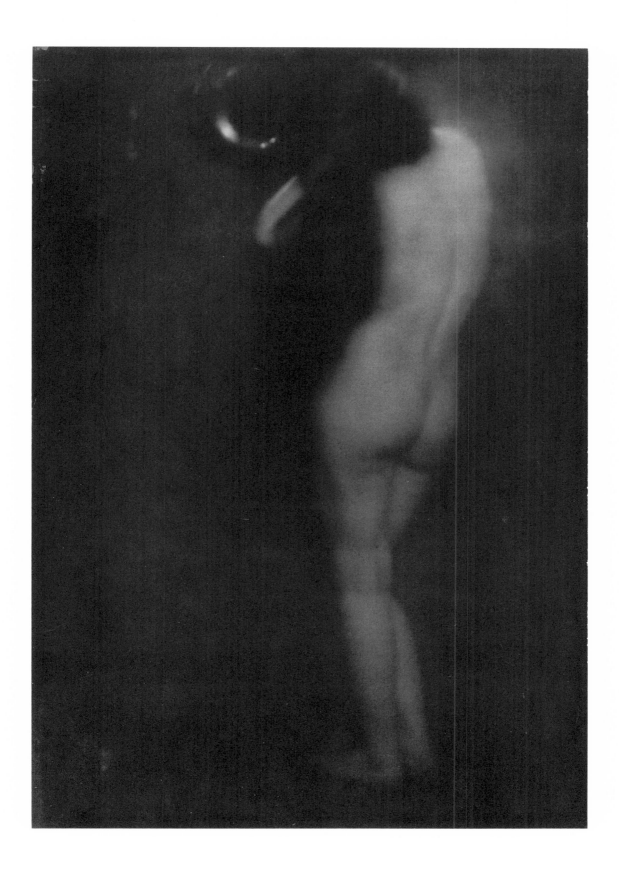

22. IN MEMORIAM. NEW YORK. 1905

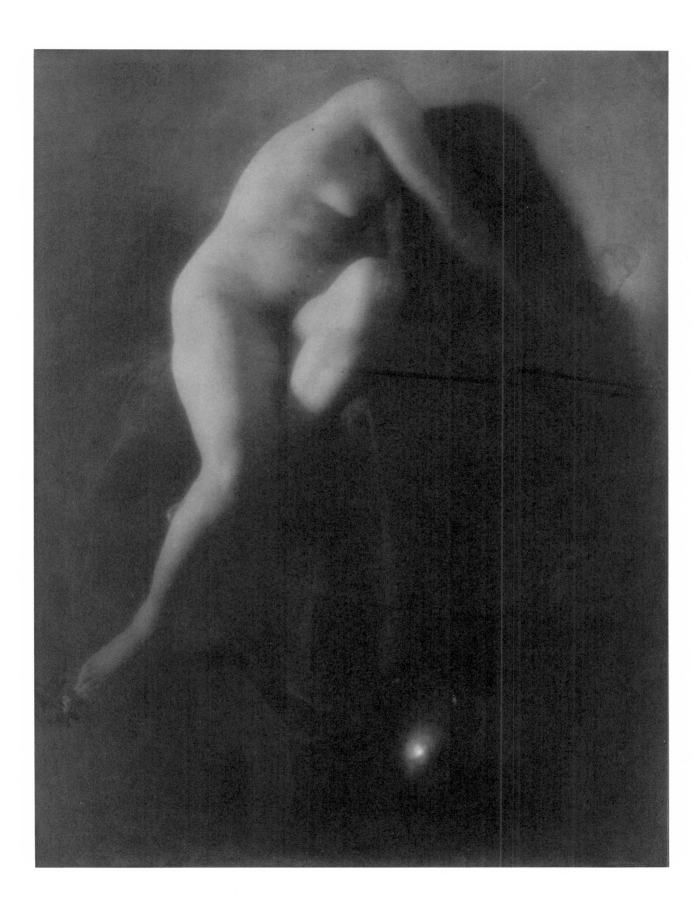

23. OTTO, FRENCH PHOTOGRAPHER. C. 1902

The photographer M. Otto ran a studio in Paris that specialized in making prints from enlarged negatives. And, as some photographic laboratories do today, he provided gallery space for his customers. Steichen had a show there in 1902. This undated letter was written to Stieglitz by Steichen sometime after returning to Paris in 1906: *Well—I've taken a job as a day laborer. I am working for Otto!!! going to put in two days a week with him for a while at $20.00 twenty dollars a day—"showing him" how to do it [make Steichen prints].*

I tell you it is not exactly pleasant but I simply had to do something—I have thought of giving up this place [103, boulevard du Montparnasse]—but find that any other place including moving etc. would be about the same in the end—and now that I have gone to the trouble and expense of making this place fine why I might as well get some of the benefit not only for our pleasure and comfort but from a business standpoint. [Steichen made his living chiefly as a portrait photographer and painter.]—There is no use denying it people have more respect in a business way for you if they think you have money enough—Oh I guess I'm talking wash but I can't see or think straight any more.

Leaves 307–08, Beinecke.

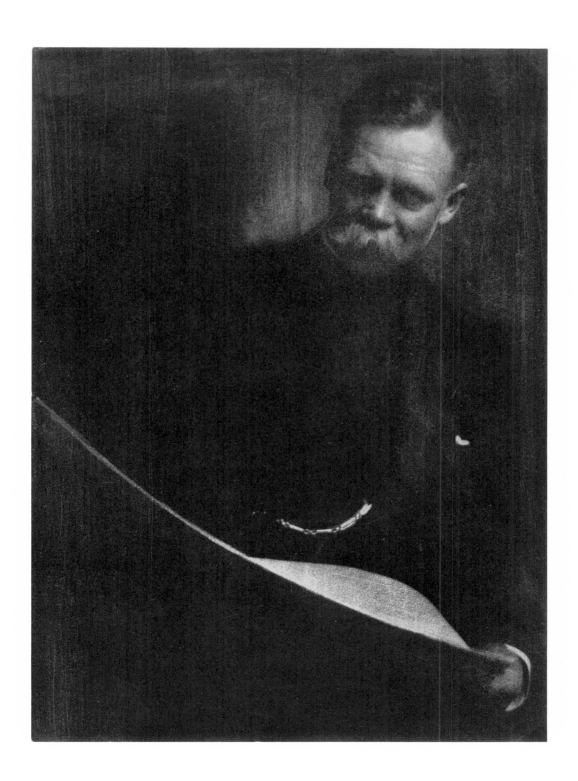

In April 1906 Stieglitz issued a deluxe volume of Steichen's work containing twenty-nine plates and an introduction by the Belgian Symbolist playwright, Maurice Maeterlinck (1862–1949). Shortly thereafter Steichen wrote Stieglitz: *Here's a line from Maeterlinck that has just come about the book—which finally reached him—I send the words to you because they are really meant for you as much as for me—in fact for all of us—even if Maeterlinck does not realize it—*

"Je reçois à l'instant votre magnifique album. C'est une admirable, un incomparable realisation d'art. Vous avez discipline directement les rayons de soleil comme un peintre discipline ses pinceaux. Je vous remerci de tout coeur de ce superbe envoi qui sera l'ornament royal de ma table de travail."

That's great—isn't it—the sort of thing that overbalances all the peanuts we have to eat. I know you are enjoying these words as much as I am. They have the significance and honesty of—nature itself—

Let's shake hands old man—and be glad—

Always your Steichen

Leaf 253, Beinecke. The Maeterlinck letter may be translated: "I received a moment ago your magnificent album. It is an admirable, an incomparable artistic realization. You have disciplined directly the rays of the sun as a painter disciplines his brushes. I thank you with all my heart for sending this superb gift, which will be the royal adornment of my work table."

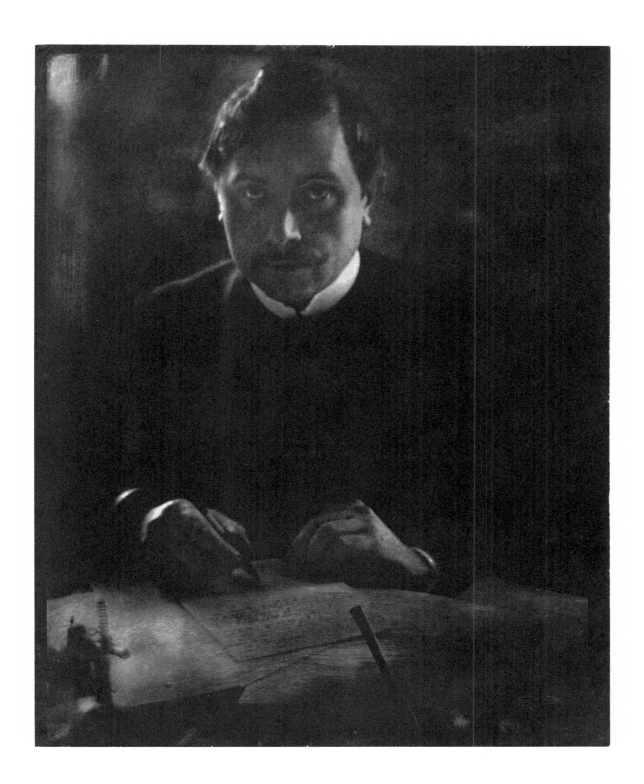

25. FRANZ VON LENBACH. MUNICH.
1903 (negative 1901)

According to his autobiography, Steichen visited Munich in 1901
to attend an exhibition of the German Secessionist painters. While
there he photographed the German portrait painter Franz von
Lenbach (1836–1904). In an article for a London periodical, in
which he refers to Lenbach, Steichen reveals his belief in the strong
relationship between painting and photography: *One need not
point to the sources of influence to be found in the American work, for
Whistler and Alexander are as much in evidence as the old masters
and the Japanese. Yet is not the movement in modern art similarly
kin to this influence? If we in America have felt this more keenly
than others it is because we have been more ready to be receptive.*

*We cannot realize that it should seem strange that, if the photog-
rapher is desirous also of being an artist, his work shall communicate
the spirit of the painter. Observe how intimate is the relation be-
tween the German painter and their school of photography. One is
continually reminded of the influence of a Boecklin, a Lenbach, or a
Leistikow. These photographers are more concerned with art than
with dark room textbooks. . . .*

Eduard J. Steichen, "The American School," *The Photogram*
(London), vol. 8 (January 1901), p. 2.

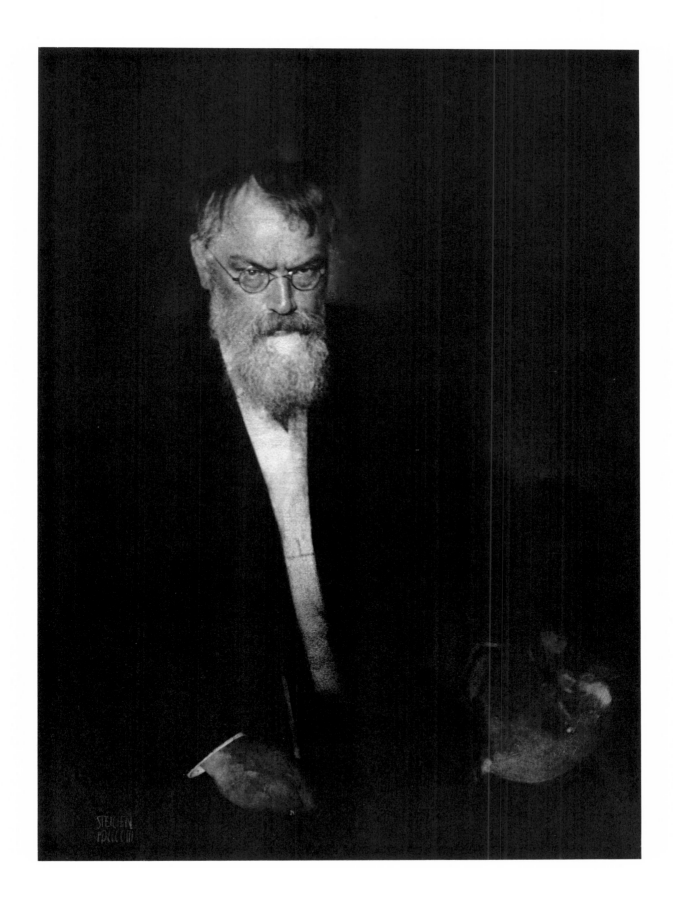

26. J. P. MORGAN. NEW YORK. 1904 (negative 1903)

Steichen described the making of this most famous portrait of the multimillionaire railroad magnate John Pierpont Morgan (1837–1913): *I suggested a different position of the hands and a movement of the head. He took the head position, but said, in an irritated tone, that it was uncomfortable, so I suggested he move his head to a position that felt natural. He moved his head several times and ended exactly where it had been "uncomfortable" before, except that this time he took the pose of his own volition. But his expression had sharpened and his body posture became tense, possibly a reflex of his irritation at the suggestion I had made. I saw that a dynamic self-assertion had taken place, whatever its cause, and I quickly made the second exposure, saying, "Thank you, Mr. Morgan," as I took the plate holder out of the camera.*

He said, "Is that all?"

"Yes, sir," I answered.

He snorted a reply, "I like you, young man. I think we'll get along first-rate together." Then he clapped his large hat on his massive head, took up his big cigar, and stormed out of the room. Total time, three minutes.

Edward Steichen, *A Life in Photography* (Garden City, N.Y.: Doubleday & Co., 1963), unpaged (Chapter 3).

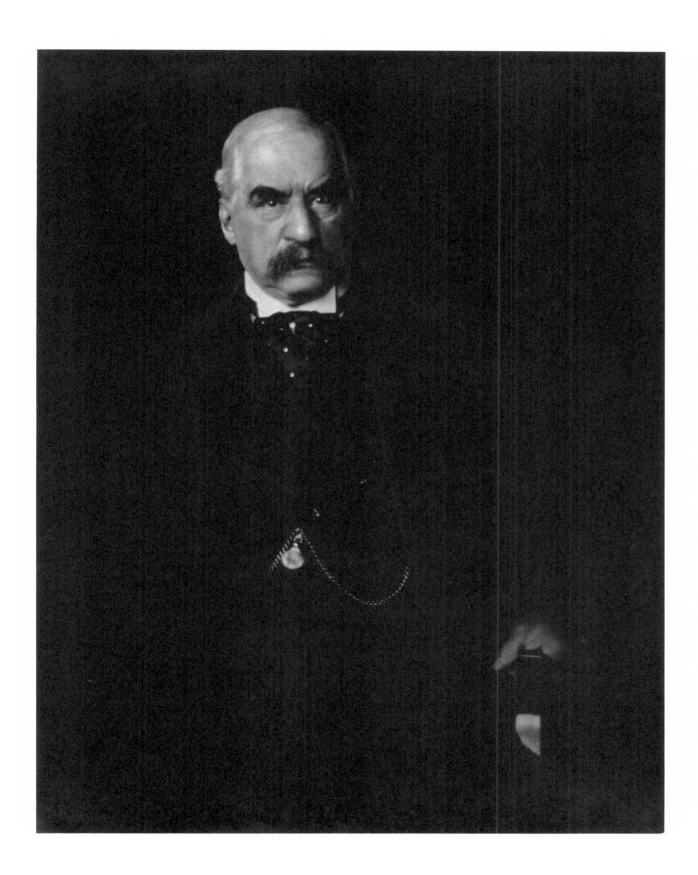

27. CLARENCE H. WHITE. 1903

Clarence H. White (1871–1925), a photographer of great talent, was a close friend of Steichen's. In the fall of 1903, Steichen and his new bride, Clara Smith Steichen, visited White's home in Newark, Ohio, on their honeymoon. This portrait probably dates from that year. It was reproduced in the January 1905 issue of *Camera Work*, following a portfolio of White's photographs.

In an editorial note, Stieglitz discussed briefly the work of both photographers in a passage that reveals one reason for the superb quality of the gravures in *Camera Work*: the use of the photographer's own negative to make the printing plate whenever possible.

Although having devoted Number III of Camera Work *to Clarence H. White's work, we felt at the time that we had not done him full justice. As he is, beyond dispute, one of the most interesting figures in the ranks of the world's pictorial photographers, our readers will undoubtedly enjoy the opportunity of studying further examples of his work. All the plates are photogravures made directly from the original negatives.*

Mr. Steichen's portrait of Clarence H. White has been similarly reproduced directly from the original negative. Thus we have six examples of the "straightest" kind of "straight photography" reproduced in these plates of Messrs. White and Steichen.

Camera Work (New York), no. 9 (January 1905), p. 55.

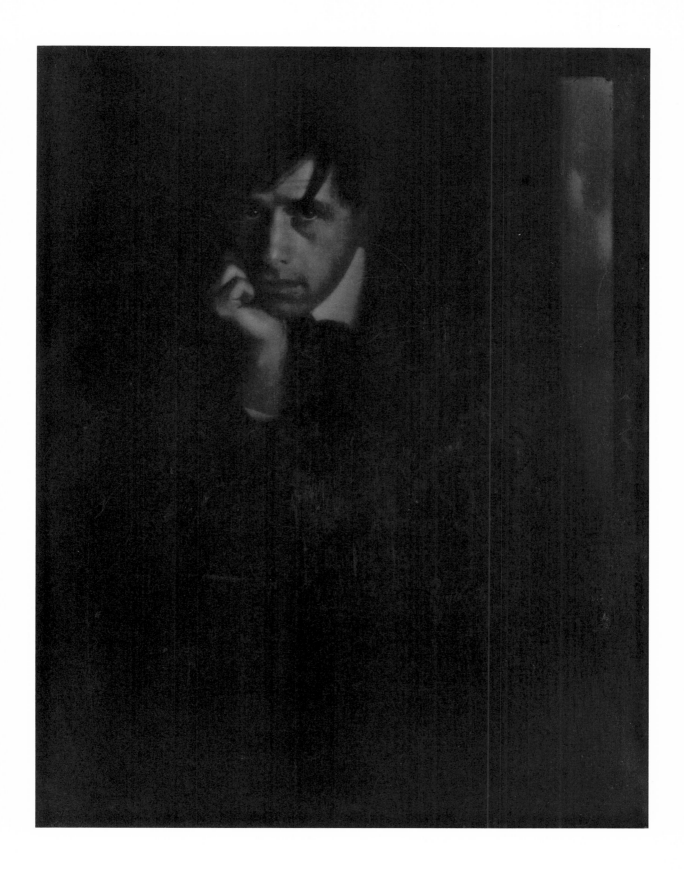

28. THE BRASS BOWL. 1904

The subject of this mystical portrait is unknown, but her meditative pose and the suggestive inclusion of the sensuously reflective bowl make this work one of Steichen's strongest Symbolist statements. It expresses perfectly the Symbolist fusion of thought and feeling that produces a mood which is peaceful yet tinged with sadness.

The Symbolist poet Maurice Maeterlinck was enthusiastic about Steichen's photographs. His essay about them ends with these words: *It is already many years since the sun revealed to us its power to portray objects and beings more quickly and more accurately than can pencil or crayon. It seemed to work only its own way and at its own pleasure. At first man was restricted to making permanent that which the impersonal and unsympathetic light had registered. He had not yet been permitted to imbue it with thought. But to-day it seems that thought has found a fissure through which to penetrate the mystery of this anonymous force, invade it, subjugate it, and compel it to say such things as have not yet been said in all the realm of chiaroscuro, of grace, of beauty and of truth.*

Maurice Maeterlinck, Supplement, *Camera Work* (New York), no. 3 (July 1903), unpaged.

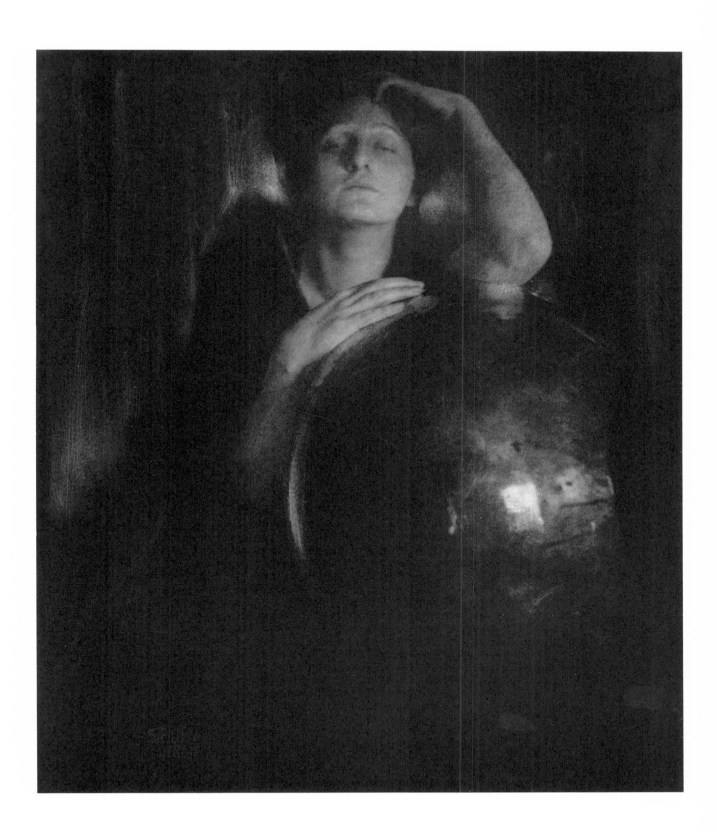

29. MERCEDES DE CORDOBA CARLES. NEW YORK.
1904

Mercedes de Cordoba (1879–1963) was the beautiful wife of the artist Arthur B. Carles, whose work prefigured much of what came to be called Abstract Expressionist. A gifted pianist and singer, Mrs. Carles was a close friend of Steichen and his wife Clara, and this exquisite portrait was made in friendship.

Both Steichen and Arthur B. Carles exhibited paintings in a nine-man exhibition arranged by Stieglitz at "291" in March and April of 1910. Stieglitz wrote about *Younger American Painters* that it was "the best possible answer to those who classed these young pioneers as common disciples of Matisse."

[Alfred Stieglitz], *Camera Work* (New York), no. 30 (April 1910), p. 54.

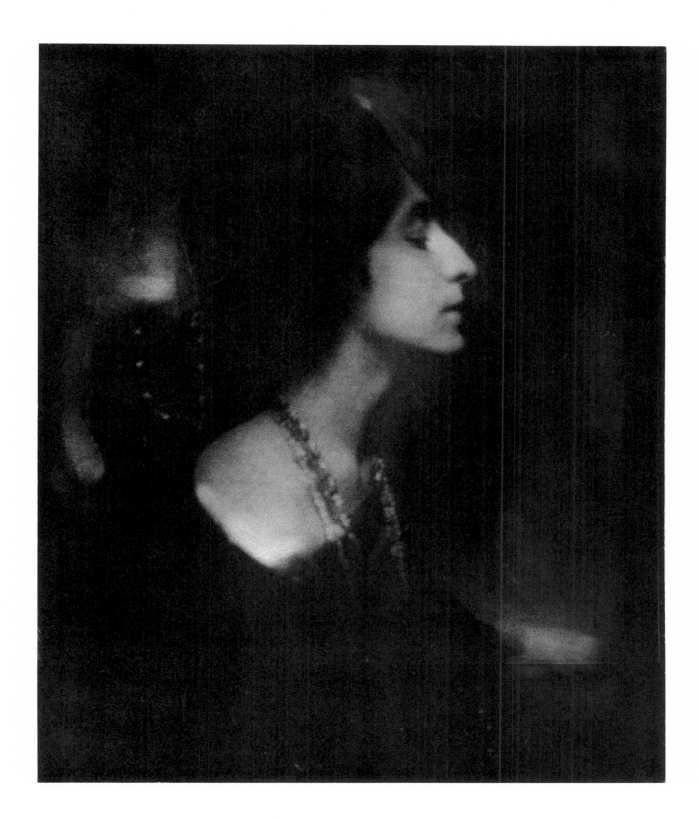

30. EXPERIMENT IN MULTIPLE GUM. 1904

The subject of this Whistleresque portrait is unknown, although we can reasonably suggest that she is an American, since Steichen at this time earned his living as a fashionable portrait photographer in New York. Her taste for Japanese prints was shared, however, by connoisseurs on both sides of the Atlantic. Technically, this print is interesting because Steichen, in a handwritten notation on the original mount, describes the three coatings of tinted gum bichromate used in making it: *Experiment in Multiple Gum / Showing color coating on edges / 1st printing solid lamp Black / 2nd printing terre verte (flat) / 3rd sepia & black (very pale) / The three printings developed mechanically / by floating paper on cold water / no local manipulation.*

31. WINTER LANDSCAPE. LAKE GEORGE. 1904–05

The first "Steichen number" of *Camera Work*, published early in 1903, contained the following epigraph reproducing Rodin's handwriting:

> *Quand l'on commence à comprendre*
> *la Nature, les progrès ne cessent plus.*
> *Aug. Rodin*

Stieglitz printed the following translation:

> *When one begins to understand nature,*
> *progress goes on unceasingly.*

Camera Work (New York), no. 2 (April 1903), before Plate 1: *Rodin* (1902).

32. MOONLIGHT—WINTER. 1902

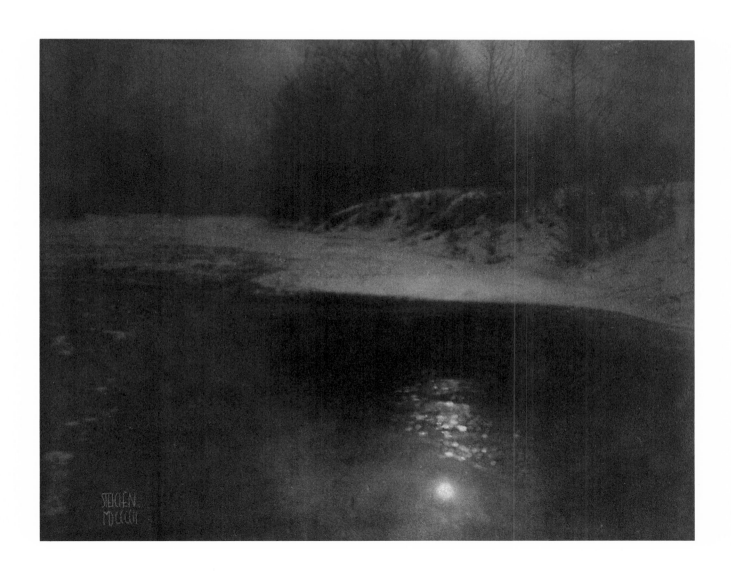

33. THE BIG WHITE CLOUD, LAKE GEORGE, NEW YORK. 1903 (dated 1902 on print)

Mr. Steichen's Big Cloud, Lake George, *is a most effective arrangement, strong and fine in color; the great mass of cumulus cloud is gloriously modeled and lit, but I am afraid I can not accept its lighting as also explaining the superbly rich black bank over which it appears. Can the time of day and strength of light that gives us the cloud be also taken as giving the impenetrable black of the shadowed bank? The water is beautifully felt and melts away into the dark most enjoyably, but I fail to account for the cloud's lighting as of the same hour.*

Frederick H. Evans, "The Photographic Salon, London, 1904, As Seen through English Eyes," *Camera Work* (New York), no. 9 (January 1905), pp. 38–39.

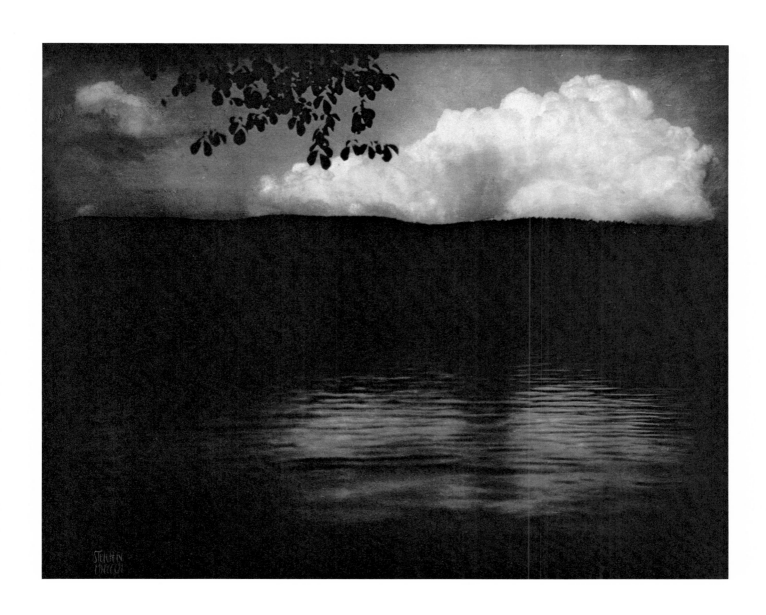

34. Garden of the Gods, Colorado. 1906

From an undated letter to Stieglitz, probably written early in 1906:

Menomonee Falls [*Wisconsin*]

My Dear A.S.

Got back Sat. from a bully fine trip of about three weeks strenuous 'sightseeing.' . . . I managed to see a lot of Nebraska, Colorado, & New Mexico, and in a way feel it is one of the greatest things I have experienced—not so much from a pictorial standpoint [as from] the bigger standpoint of life. . . . I don't know which impressed me most—the prairie or the mountains—one bigger than the other—together forming a boundless whole. . . . Somehow since I have been west I almost regret going to Paris—or Europe. I tell you one builds up a big wholesome respect and appreciation of those early settlers —My God what men & women they must have been.

Leaf 263, Beinecke.

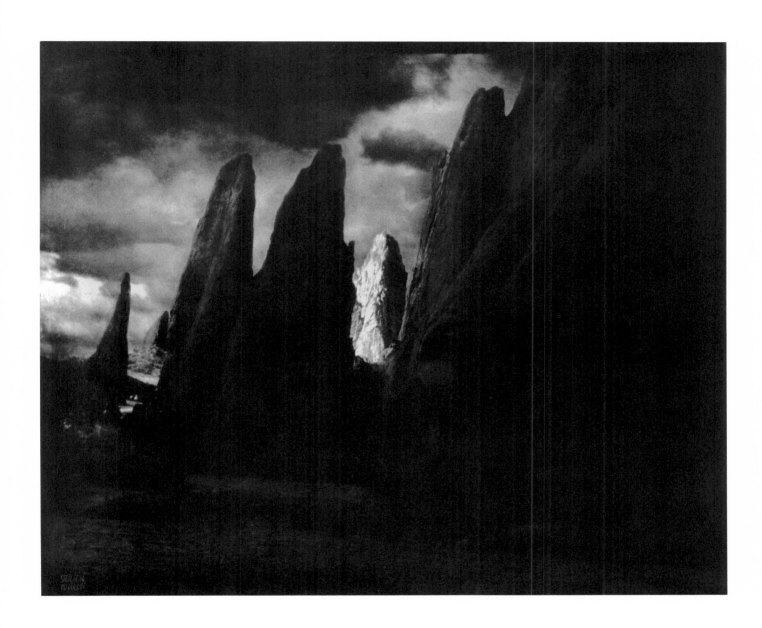

35. MOONRISE. MAMARONECK, NEW YORK. 1904

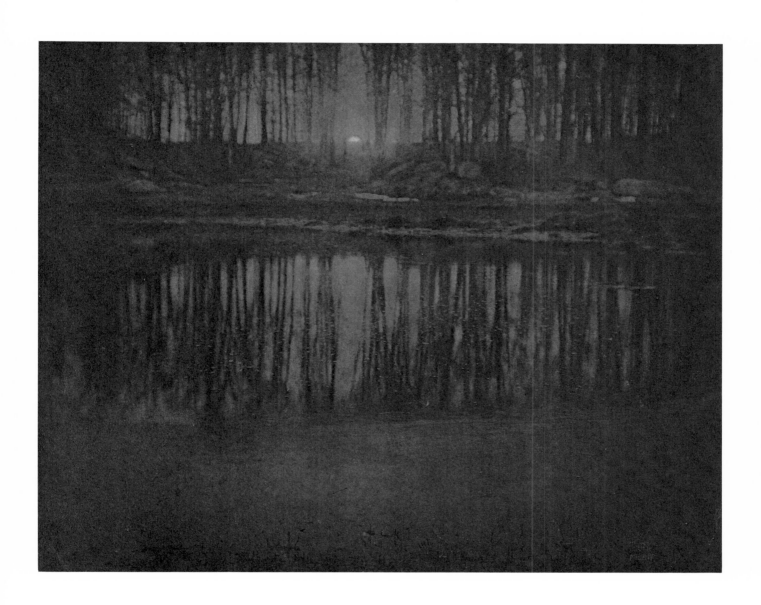

36. STEICHEN AND WIFE CLARA ON THEIR HONEYMOON. LAKE GEORGE, NEW YORK. 1903

While on his honeymoon in 1903, Steichen wrote to Stieglitz from the Lake George, New York, house belonging to Stieglitz's father: *We had a moon night before last—the like of which I had never seen before—the whole landscape was still bathed in a warm twilight glow—the color was simply marvelous in its dark bright—and into this rose a large disc of brilliant golden orange in a warm purplish sky—Gold—and we both rose and floated off into it deliciously—languidly—like the wild ducks that sailed by.*

Everything is so magnificent—so lavish—one can't help responding to it. Under the yellow and orange red maples everything seems transparent with the glow, so that one becomes part of the glow oneself.

Leaves 35–36, Beinecke.

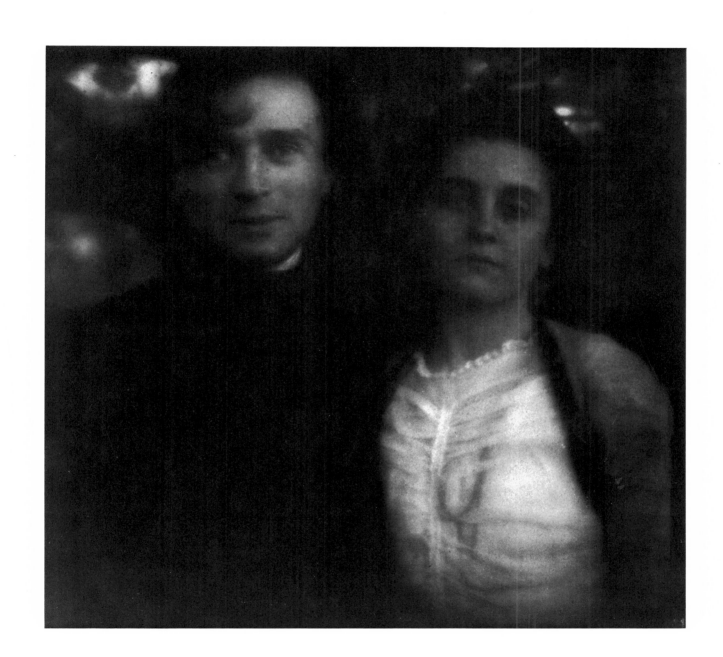

37. HORSE CHESTNUT TREES. LONG ISLAND.
1905 (negative 1904)

Again, in the latest exhibition there were still some nocturns, which were preferred by many people who have got the nocturnal habit and are disinclined to change. But the pictures in this genre were in the minority and did not represent the chief interest to those who are watching Steichen's growth. Evidence of the latter they found in his subjects of radiant or softened sunlight. These represented a distinct step in advance, because they showed the attack upon a problem at once more difficult and more vital. Psychologically speaking, it is to express the spirituality of things plainly seen; to extract from the concrete appearances of daylight their abstract expression. Technically, it is to escape from the arbitrary restrictions of tonality and to harmonize the conflicts of local color, seen in the glow of natural light.

Charles H. Caffin, "The Art of Eduard J. Steichen," *Camera Work* (New York), no. 30 (April 1910), p. 34.

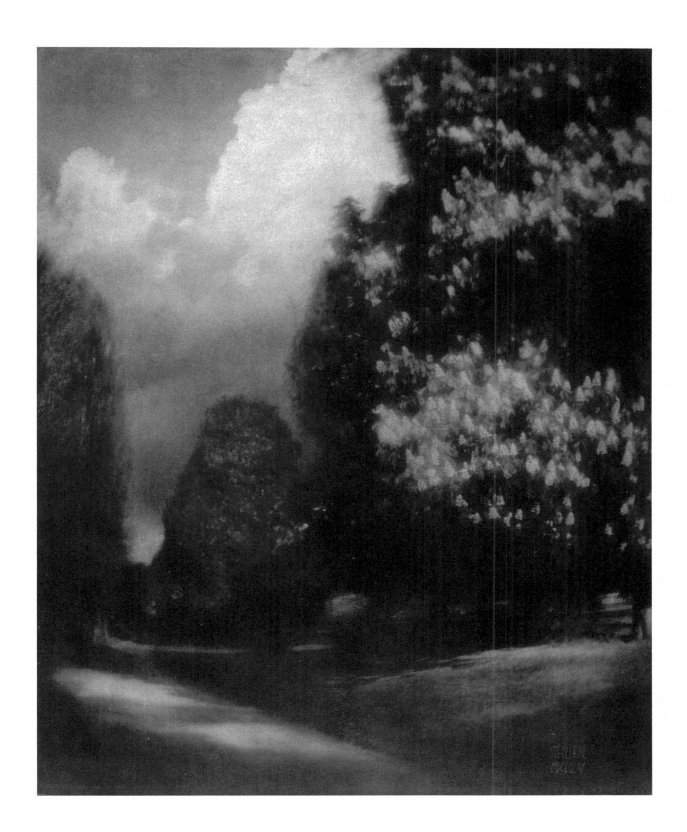

38. MARY STEICHEN AND HER MOTHER.
HUNTINGTON, L.I. 1905–06

THE SKYLARK

Oh, the skylark, the skylark,
The beautiful skylark
I heard in the month of June,
It was nothing but a dark, dark
Speck. And nothing but a tune.
And Oh! If I had some wings
I would fly up to him
And I would look down upon the things
Until the day grew dim.

Mary Steichen (age not quite nine).

Camera Work (New York), nos. 42/43 (April–July 1913), p. 14.

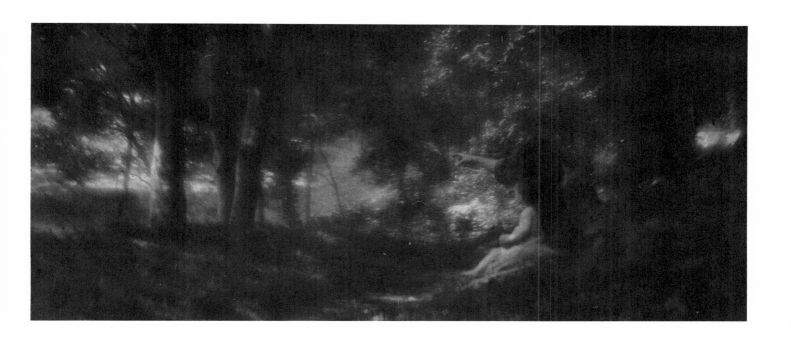

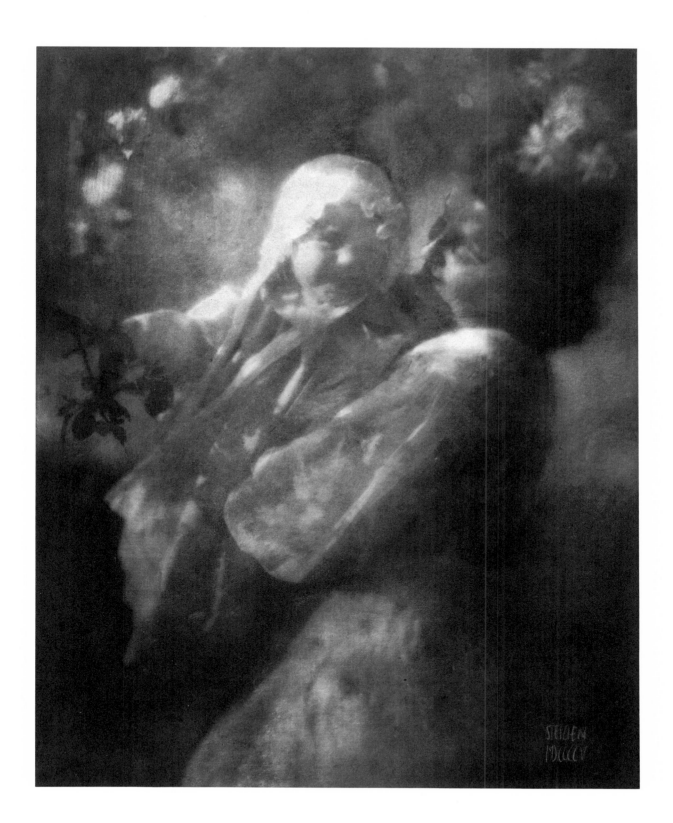

40. Mrs. Stieglitz and Her Daughter. 1904 (dated 1903 on print)

Alfred Stieglitz married Emmeline Obermeyer, a young New Yorker of twenty, nine years his junior, in 1893. Five years later their only child, a daughter named Katherine—but called Kitty—was born. Stieglitz and Emmeline eventually divorced, and of Kitty, Stieglitz's biographers are strangely silent.

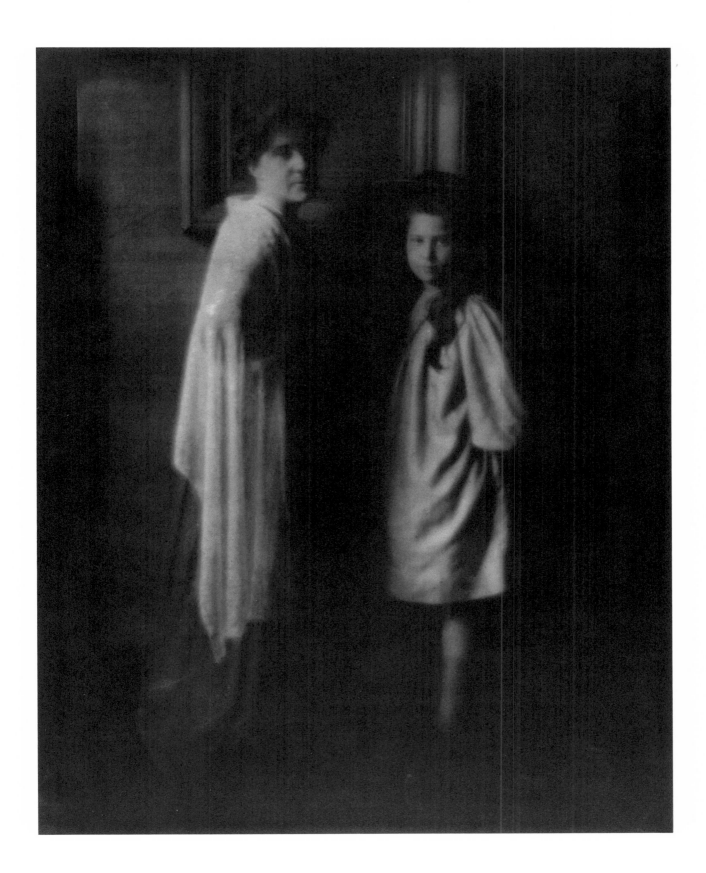

41. ALFRED STIEGLITZ AND KITTY. NEW YORK.
1905 (negative 1904)

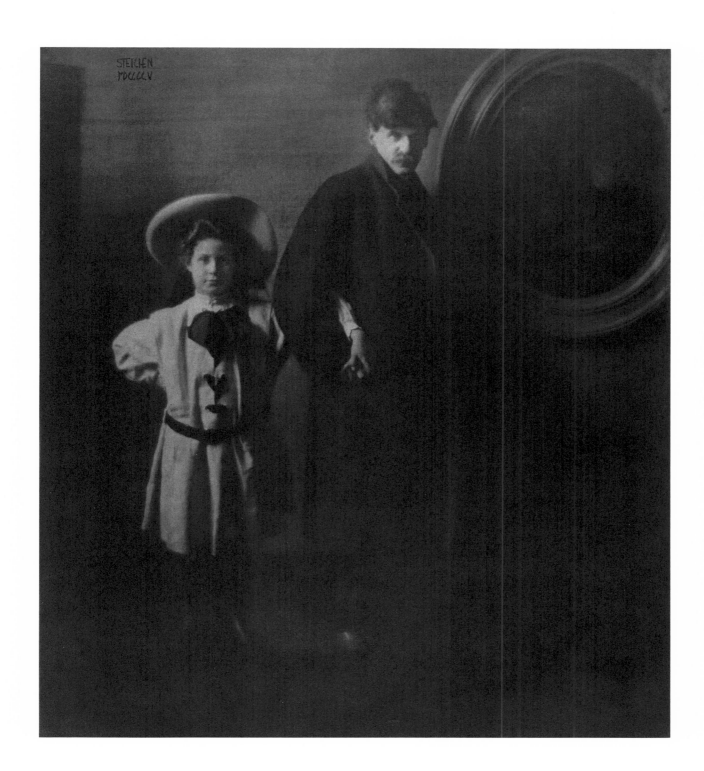

42. Alfred Stieglitz and Kitty. New York. 1905 (negative 1904)

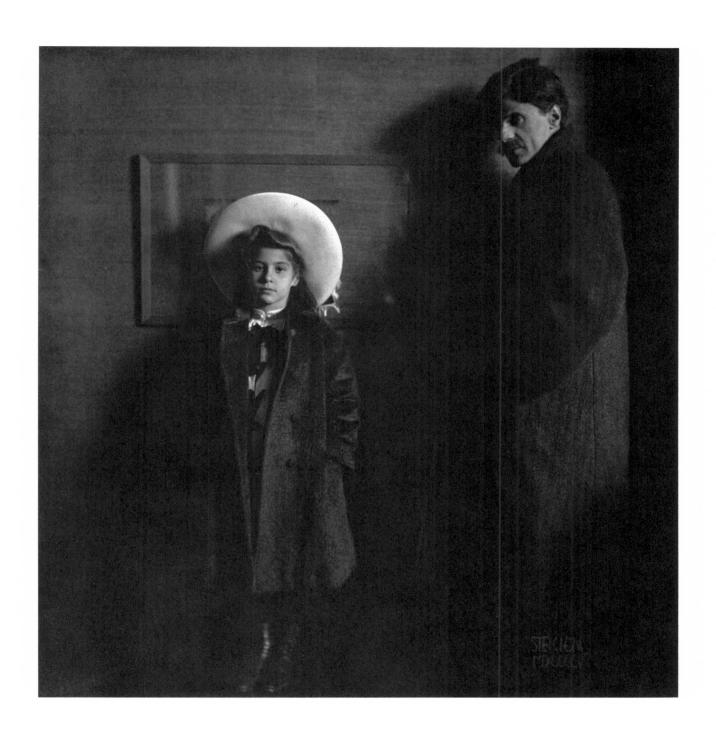

43. ALFRED STIEGLITZ AND KITTY. NEW YORK. 1905 (negative 1904)

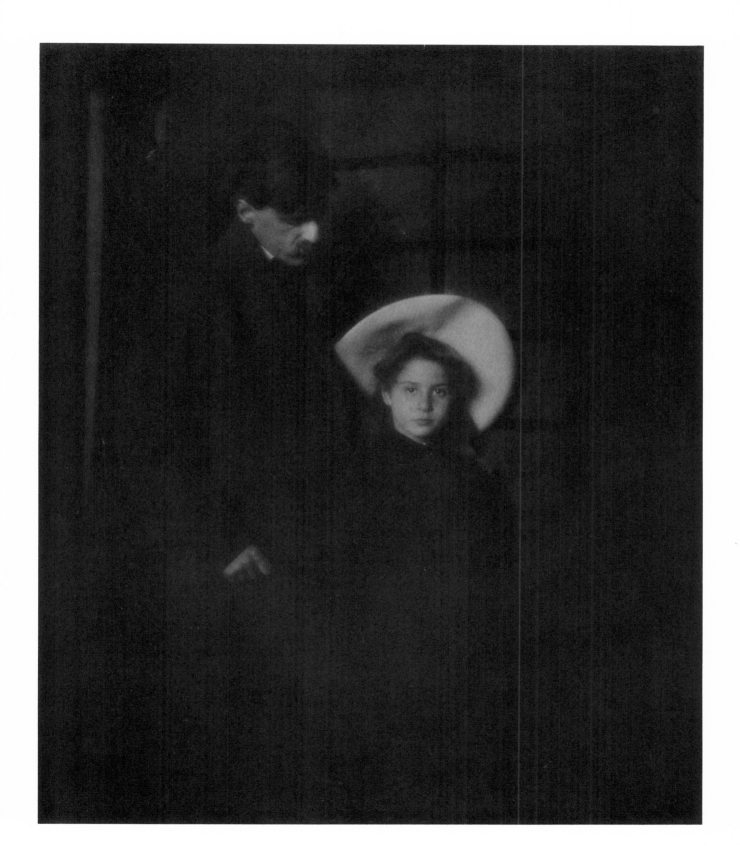

44. SADAKICHI HARTMANN. 1903

A Monologue

 Scene: Fifth Avenue, between Thirtieth and Thirty-first
Streets [the location of 291 Fifth Avenue, Steichen's residence
and studio from 1902 to 1905]
 Enter Hamlet-Steichen, wearing a Japanese obi as a necktie.

To paint or photograph—that is the question:
Whether 'tis more to my advantage to color
Photographic accidents and call them paintings,
Or squeeze the bulb against a sea of critics
And by exposure kill them? To paint—to "snap":—
No more; and, by a snap, to say we end
The heartache, and the thousand natural shocks
That art is heir to—'tis a consummation
Devoutly to be wish'd. To paint—to snap;
Perchance to tell the truth;—aye! there's the rub.
How may a fact be lost in fuzziness
When we have cast aside the painter's brush
Must give us pause: There's the respect
That makes picture-painting of so long life;
For who would bear the whips and scorns of time,
The dealer's wrong, the patron's proud contumely,

The pangs of despised art, the cash's delay,
The "nerve" of the profession, and the spurns
That patient merit of the unworthy takes,
When he himself might triumph over all
With a base camera? Who would brushes clean?
To grunt and sweat in schools or studios,
But that photograms were not dependent
On some manual fake: Photography turned painting;
Paintographs or photopaints; a sad plight,
Which makes me rather bear (at times) the painter's ills
Than turn entirely secessionist.
Thus prudence makes chameleons of us all;
And thus my native store of "fakey" talents
is sicklied o'er with scarcity of tricks;
And enterprises of great moment to A.S.,
with this regard, their currents turn awry
And lose the name: artistic. Soft you now!
The Käsebier, austere, comes down the street. Nymph of Newport,
In thy brownish tints be all my sins remembered!

 Sadakichi Hartmann

Camera Work (New York), no. 6 (April 1904), p. 25.

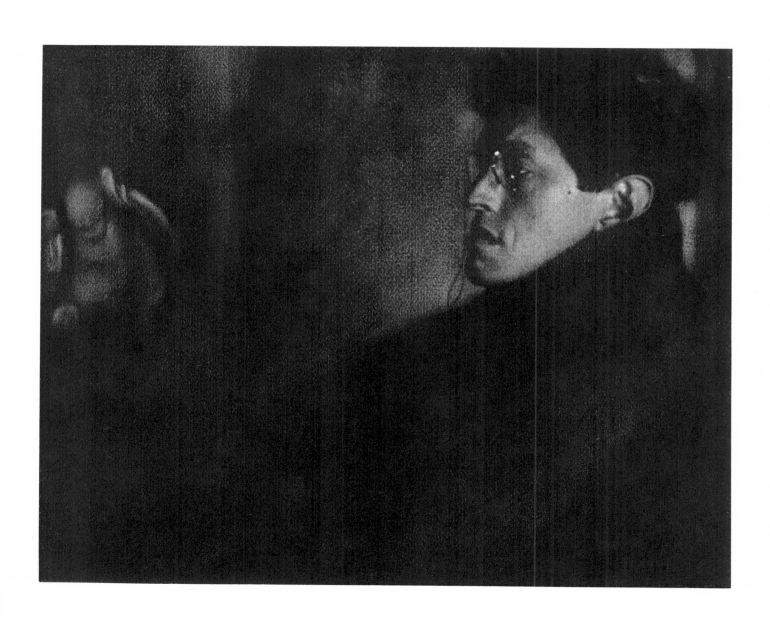

45. RICHARD STRAUSS. NEW YORK.
1906 (negative 1904)

Reviewing the London Salon of 1904, the noted photographer
Frederick H. Evans wrote: *The* Richard Strauss, *No. 125, is*
evidently a carefully worked out symbolic version. I would have
preferred another treatment, for like though it certainly is, it is too
little important in that aspect to have any great value as a portrait.
My own seeing of the great composer when conducting or
accompanying at the piano gave him to me as a much more cheerful
person; and when in the throes of composing, say such a tremen-
thing as his Ein Heldenleben, *I should not believe him to be fond*
of so "forcing the note" as this study gives him out to be doing. I
suppose the flame-like high lights around the head are to symbolize
the musical emanations from his tireless brain. How clever, almost
too clever, it all is, and how infinitely I for one would prefer the
treatment of the Chase or the Lenbach or the first Rodin, three
superb and unquestionable masterpieces!

Frederick H. Evans, "The Photographic Salon, London, 1904, As
Seen through English Eyes," *Camera Work* (New York), no. 9
(January 1905), p. 39.

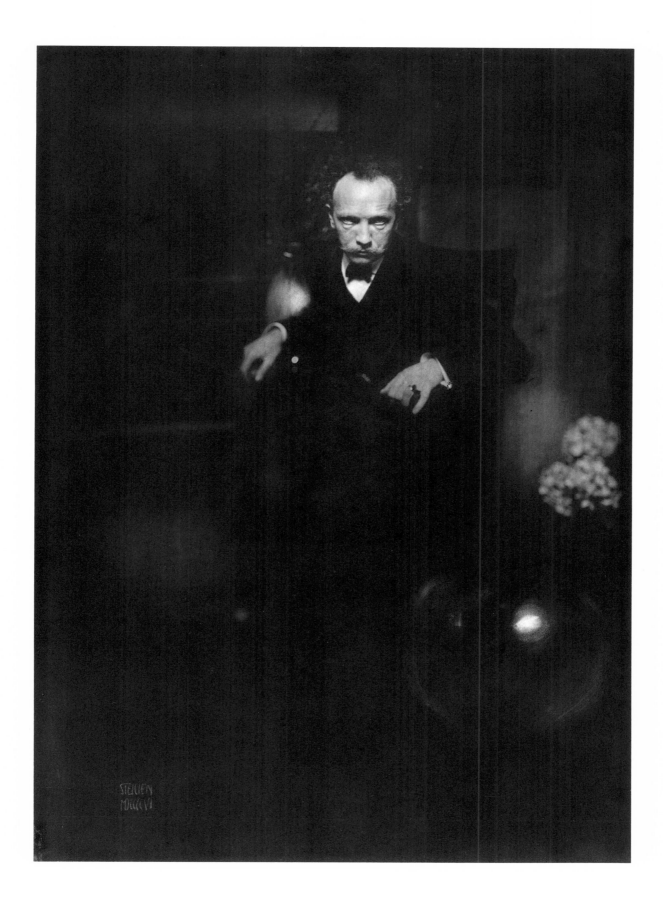

46. RODIN. PARIS. 1907

I believe that photography can create works of art, but hitherto it has been extraordinarily bourgeois and babbling. No one ever suspected what could be gotten out of it; one doesn't even know today what one can expect from a process which permits of such profound sentiment, and such thorough interpretation of the model, as has been realized in the hands of Steichen. I consider Steichen a very great artist and the leading, the greatest photographer of the time. Before him nothing conclusive had been achieved. It is a matter of absolute indifference to me whether the photographer does, or does not, intervene. I do not know to what degree Steichen interprets, and I do not see any harm whatever, or of what importance it is, what means he uses to achieve his results. I care only for the result, which however, must remain always clearly a photograph. It will always be interesting when it be the work of an artist.

Auguste Rodin

George Besson, "Pictorial Photography: A Series of Interviews," *Camera Work* (New York), no. 24 (October 1908), p. 14.

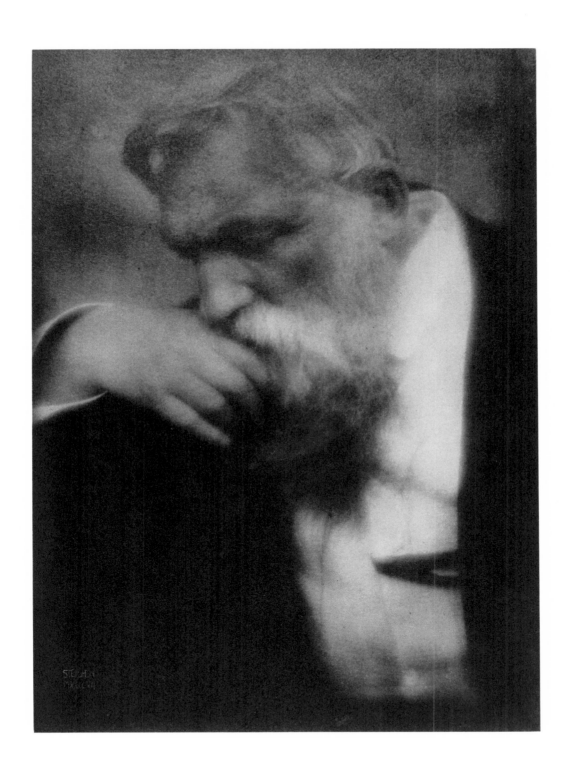

47. Agnes Ernst Meyer. 1906–08

Agnes Ernst had become a part of the Stieglitz circle after having interviewed him for an article published in the *New York Sun*. She later married the paper's owner, Eugene Meyer, and Steichen photographed her in 1910 in her wedding gown (pl. 57). Steichen wrote Stieglitz, sometime after 1906, from his studio at 103, boulevard du Montparnasse, Paris: *A Mr. Mayer—brother of Mrs. Blumenthal [—] was in today to be photographed and bought 2 large prints of the Rodin portraits—He came with Miss Ernst— "the girl from the Sun." And he left an order for me to do her for him.*

Leaf 213, Beinecke.

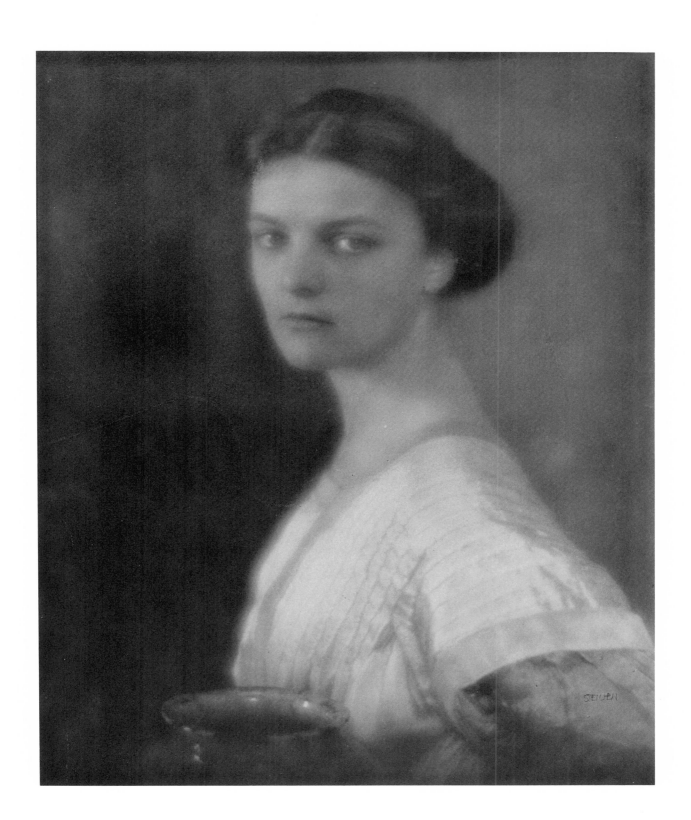

48. THE PHOTOGRAPHER'S BEST MODEL:
GEORGE BERNARD SHAW. LONDON. 1907

July 13, 1907

My Dear A.S.—

*Well I've seen and done Shaw (photographically of course)—
He's all I expected him to be—both ways—Thin—tall—lanky—
very light reddish hair & beard—turning very white—gives him a
very airy appearance unlike his photographs—in fact from that
standpoint he is impossible I think—Even a colour plate I made of
him fails to give the true impression. He's the nicest kind of fellow
imaginable—genial and boyish—there is a little of the sardonic about
him as you see him but when you get the camera at him you are
tempted with the possibilities in that way—He said '[Alvin Langdon]
Coburn will be very much cut up when he hears you've done me—
you know he considers me his special property.''—He seems to
know a lot about photography and certainly skillfully bluffs you into
believing he knows it all. . . .*

Leaf 104, Beinecke.

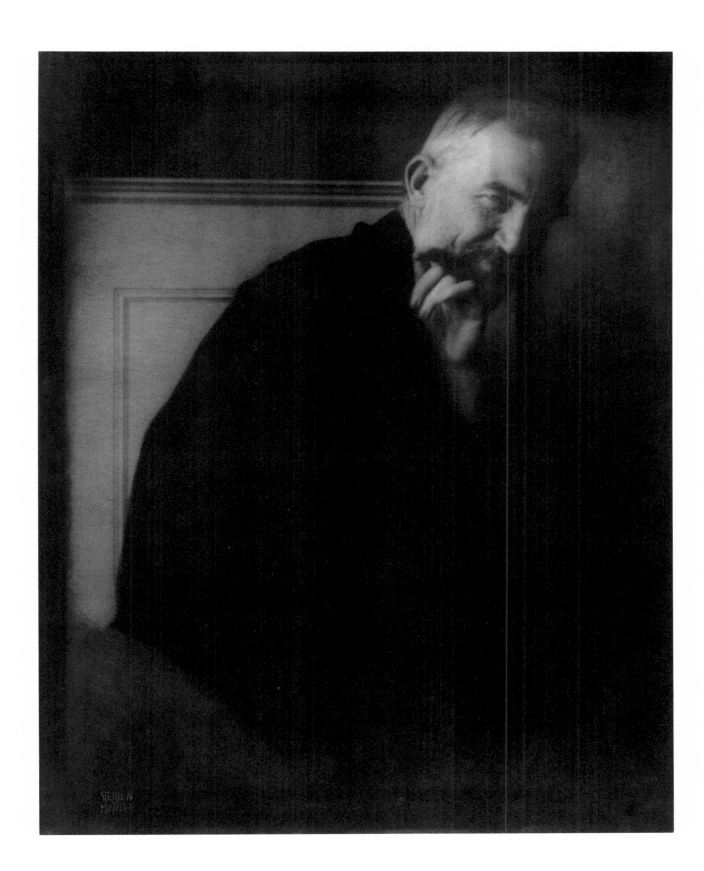

49. Mrs. Condé Nast. Paris. 1907

Steichen's relationship with magazine publisher Condé Nast was established as early as May 24, 1906, the date a special "outing" number of *Vogue* magazine appeared with a color lithograph of a Steichen painting on its cover. In 1923, Steichen began full-time his celebrated career as a fashion photographer for *Vogue* and a photographer of celebrities for *Vanity Fair*, two of the magazines published by Condé Nast. Steichen retired from the Nast organization in 1937, and upon submitting his letter of resignation he received this letter of appreciation from Nast.

September 27, 1937

Dear Edward:

. . . I remember, as if it were yesterday, our luncheon together at old Delmonico's, when I first tried to seduce you into becoming a professional photographer, at the expense of your career as a painter. What a fortunate thing for me that you were weak and surrendered to my solicitations! I believe that that luncheon did more to further the art and progress of photography in America than any other single event or agency in the past quarter century. . . . Affectionately and gratefully yours,

Condé

The Steichen Archive, The Museum of Modern Art, New York.

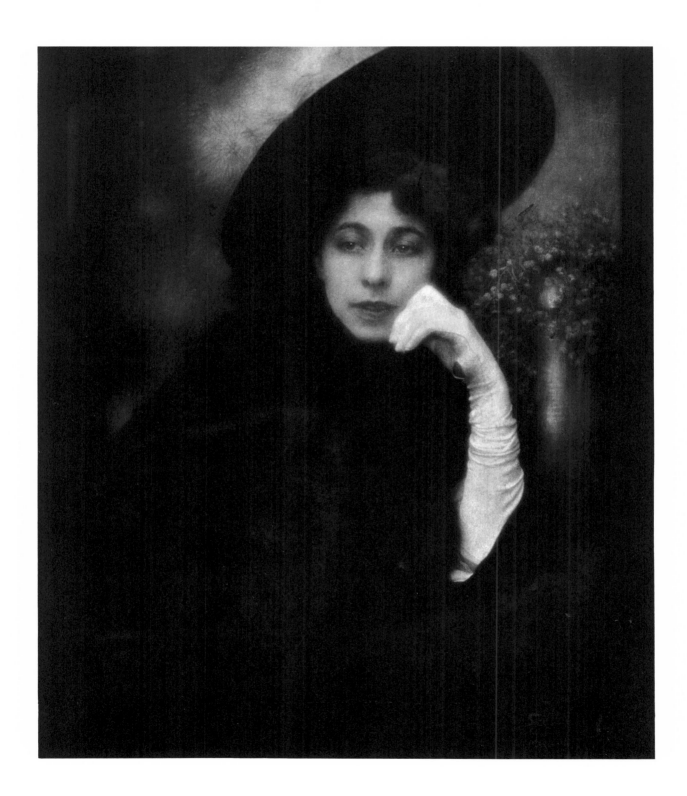

50. CYCLAMEN — MRS. PHILIP LYDIG. NEW YORK.
C. 1905

Rita de Acosta Lydig (1880–1929), a woman celebrated for her
extravagant ways with money, for her impeccable taste in clothes,
objets d'art, and dinner guests, and for her dark beauty, lived
sumptuously in New York and Paris in the first three decades of
this century. She loved white flowers—cyclamen, lilies, gardenias,
and lilies of the valley—and she would spend a thousand dollars a
month for the flowers that filled her Stanford White house on East
52nd Street, where this photograph was probably made. That this
élégante, who tipped her dressmakers with loose emeralds, would
decide to be photographed by Steichen shows how very successful
he was as a celebrity portrait photographer, his primary profession
in the years in New York between 1902 and 1906.

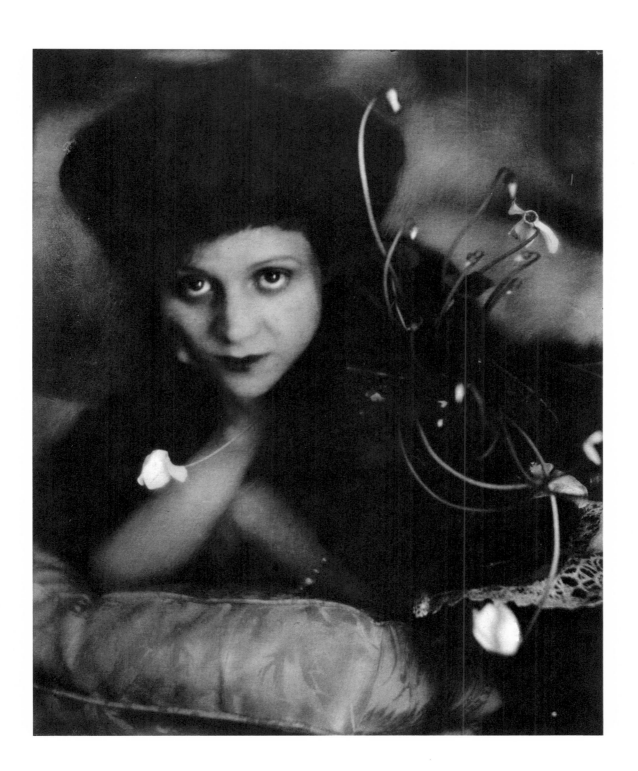

51. LILLIAN STEICHEN, MENOMINEE FALLS, WISCONSIN. 1907

Steichen made this portrait of his sister, then a student at the University of Chicago, the year before her marriage to the poet Carl Sandburg. Miss Steichen's youthful socialist idealism is evident in this essay she wrote for the second issue of *Camera Work* and the first to feature Steichen's work.

OF ART IN RELATION TO LIFE

Art may, perhaps, be explained as the self-realization of personalities whose experiences are of such surpassing nature that they can not be expressed adequately by the ordinary ways of social intercourse and utilitarian production. A subtler medium is required to transmit the thoughts and feelings of the artist-soul in their intense individuality, and with exactly that poise between definiteness and vagueness in which they were conceived. Has the painter felt the dim, soft benison of hope—it stands confessed in the "Hope" of a Watts. Did Shelley experience an agony of yearning for an elusive vision of ideal perfection—in "Alastor," in "Epipsychidion" he has expressed it. . . . This, then, is the burden of art: "Lo—the Beautiful and the Good. . . .

Camera Work (New York), no. 2 (April 1903), p. 30.

52. PORTRAIT OF MY MOTHER. MILWAUKEE. 1908

From an unidentified newspaper clipping (probably from the early fall of 1902) in the scrapbook assembled by Steichen's mother:

A MASTER OF PHOTOGRAPHY

Edward J. Steichen Now Has World-Wide Reputation. Young Milwaukee Artist who Attracted Attention in Foreign Capitals is Now Visiting His Mother Here—High Praise from World's Greatest Critics

The gray linen shirt with loose "Kimono" sleeves, short turnover collar and black ribbon scarf at the throat, to say nothing of hair of a significant length and degree of unkemptness, would have proclaimed Edward J. Steichen, the artist, even if he had not been caught this morning in the act of placing a large photographic plate holder in a favorable position in the sunlight before his mother's home, 423 Fifteenth Street. . . . During the two years abroad the young Milwaukee artist has made the acquaintance of and photographed nearly all the personages known to Paris. . . .

Just before Mr. Steichen left Paris, Rodin gave a luncheon for him to which were bidden all the artists of note in Paris, and the great master embraced the young American and hoped to see him back soon. Maeterlinck, the Belgian Symbolist, is also a friend of his, and it is Steichen's picture of the author [pl. 24] which makes the frontispiece for the English edition of Maeterlinck's latest book. . . .

Mr. Steichen is the more wonderful, in that he is self taught, and except for a month at Julien's in Paris has had no instruction. He has no use for and says that Julien's has killed more artists than one can number. Mr. Steichen works slowly, not making more than one print a day, and seldom more than two or three a week. This compared with the amount usually turned out by photographers, will give an idea of the care bestowed on the prints as well as a clue to their money value.

The Steichen Archive, The Museum of Modern Art, New York.

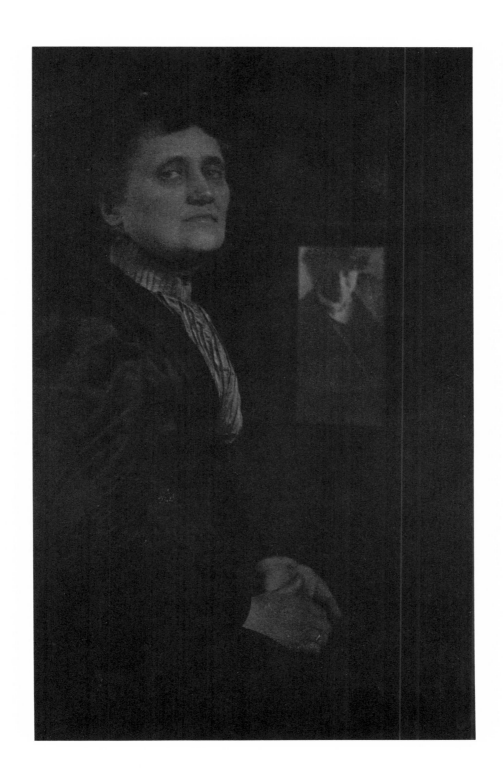

53. FRENCH PEASANT WOMAN. C. 1907

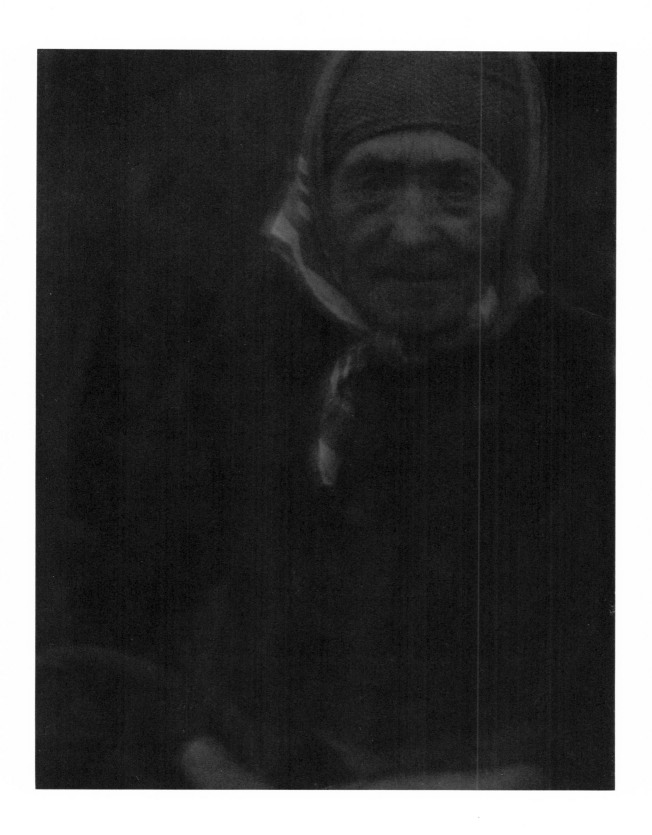

54. STEEPLECHASE DAY, PARIS: AFTER THE RACES.
1907

One day in the summer of 1907, I borrowed from a friend a German hand camera called the Goerzanschutz Klapp Camera. Armed with this camera, I made my first attempt at serious documentary reportage. I went to the Longchamps Races and found an extravagantly dressed society audience, obviously more interested in displaying and viewing the latest fashions than in following the horse races.

Edward Steichen, *A Life in Photography* (Garden City, N.Y.: Doubleday & Co., 1963), unpaged (Chapter 4).

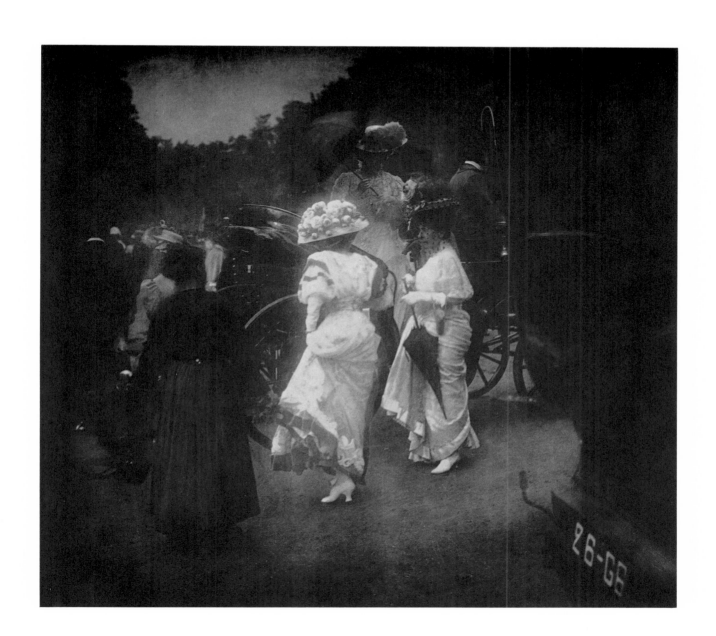

55. STEEPLECHASE DAY, PARIS: GRANDSTAND. 1907

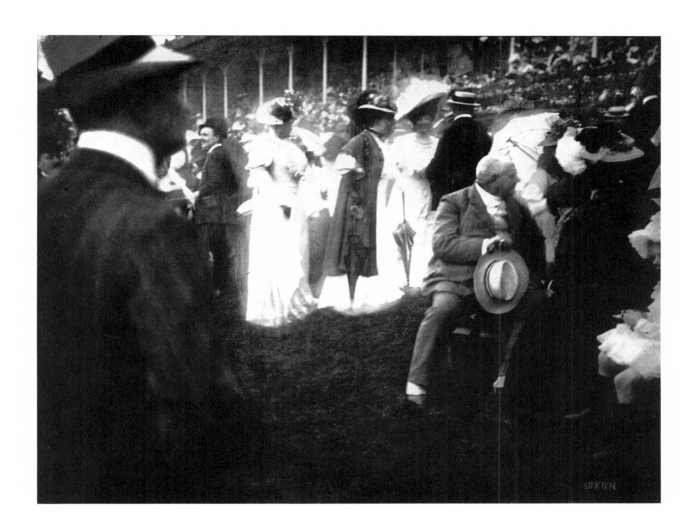

56. THE FLATIRON. 1905

Daniel H. Burnham (1846–1912) designed this structure for a triangular area bound by Broadway and Fifth avenues between Twenty-second and Twenty-third streets in New York City. It was completed in 1902.

At all events, it is a building—although belonging to no style to be found in handbooks or histories of architecture—which, by its peculiar shape and towering height, attracts the attention of every passerby. True enough, there are sky-scrapers which are still higher, and can boast of five or six tiers more, but never in the history of mankind has a little triangular piece of real estate been utilized in such a raffiné *manner as in this instance. It is typically American in conception as well as execution. It is a curiosity of modern architecture, solely built for utilitarian purposes, and at the same time a masterpiece of iron-construction. It is a building without a main façade, resembling more than anything else the prow of a giant man-of-war. And we would not be astonished in the least, if the whole triangular block would suddenly begin to move northward through the crowd of pedestrians and traffic of our two leading thoroughfares, which would break like the waves of the ocean on the huge prow-like angle. . . .*

Sidney Allan [Sadakichi Hartmann], "The 'Flat-Iron' Building: An Esthetical Dissertation," *Camera Work* (New York), no. 4 (October 1903), p. 36.

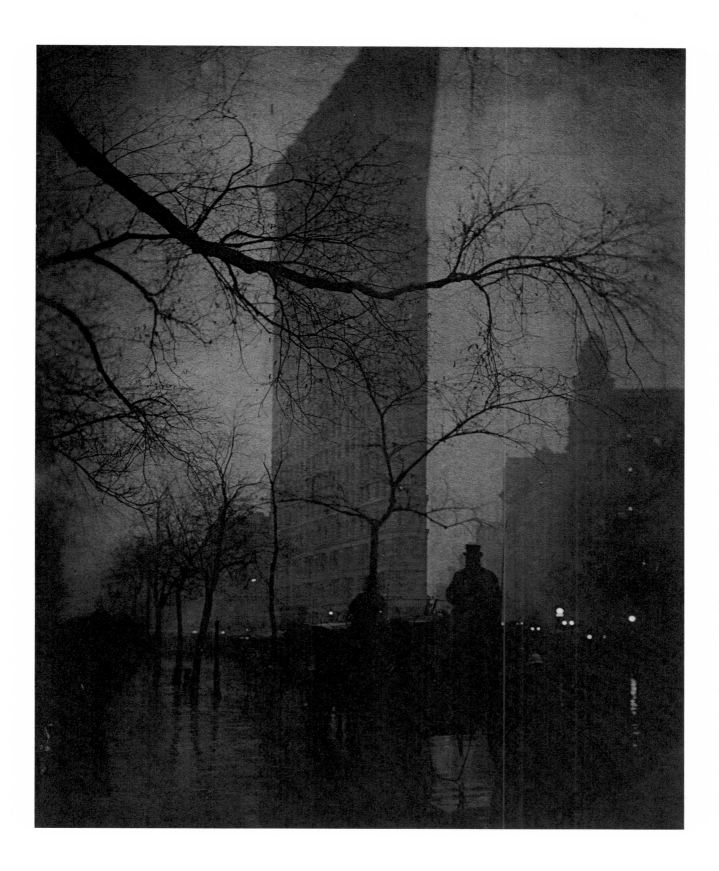

Early in 1912 Steichen wrote Stieglitz about a visit to London with
Eugene Meyer who, two years earlier, had married Agnes Ernst,
"the Girl from the Sun." Steichen advised them on the art they
purchased: *I tried to get Vollard [Cézanne's Paris dealer] to
bring over to London a few Cézannes. . . . I was so insistent on one
Cézanne stillife—that Meyer practically gave me the order to get it
—but I am sending him the photos of it first—I don't want to appear
too aggressively cock sure—even if I do feel it* myself—*It is the
finest stillife Cézanne ever painted I am sure—and I don't know
if anyone but Chardin ever painted as good a one—and I'd rather
have a Cézanne than a Chardin. If they take that picture America
will have a Cézanne—for fair—I don't think I should have taken
that attitude about anything else.*

Leaf 259, Beinecke.

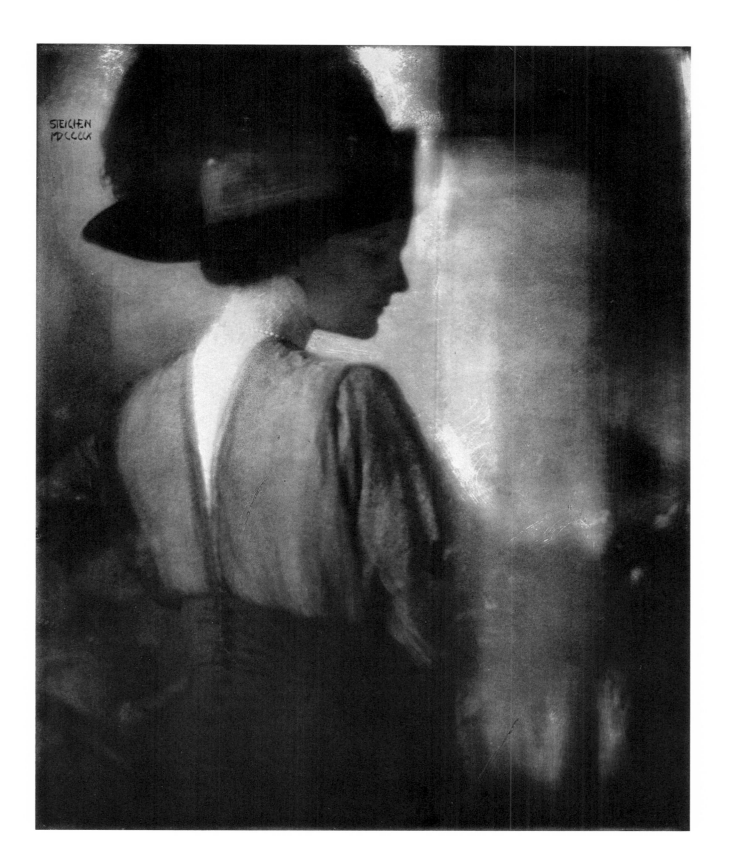

58. Landon Rives — Melpomene. 1903

Melpomene, one of nine Greek Goddesses, all daughters of Zeus and Mnemosyne, had as her domain the art of Tragedy. We might suppose, therefore, that Landon Rives appears here as an actress, a player of tragic roles. Perhaps, as an amateur, she was. Of all the subjects of Steichen's large and dramatic portraits, none is as obscure as the dour Miss Rives. We know only that she was reputed to be wealthy, a friend of F. Holland Day and Alvin Langdon Coburn, liked photography, and that her family owned an estate in Virginia called Castle Hill.

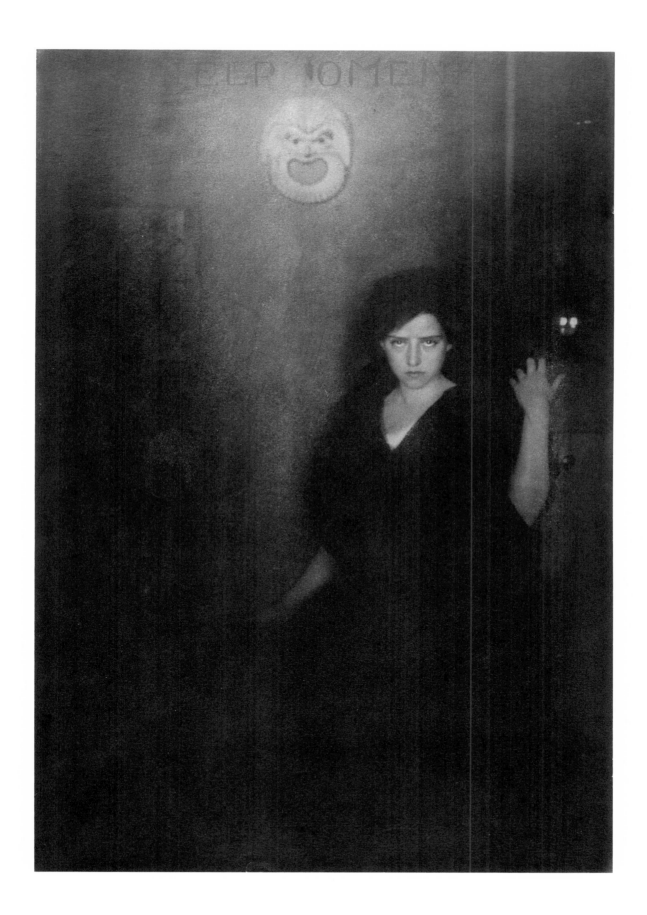

59. Lady Ian Hamilton. London. 1907

Steichen made this imposing portrait shortly after his photograph
of George Bernard Shaw (pl. 48), for in the same letter to Stieg-
litz describing his session with Shaw, Steichen adds the following:
Staying over till Tuesday as I finally got an order *and the
appointment was for Tuesday. (Lady Hamilton)—I felt I must stay
to try and get my expenses out of the d--n trip at least.*

Leaf 105, Beinecke.

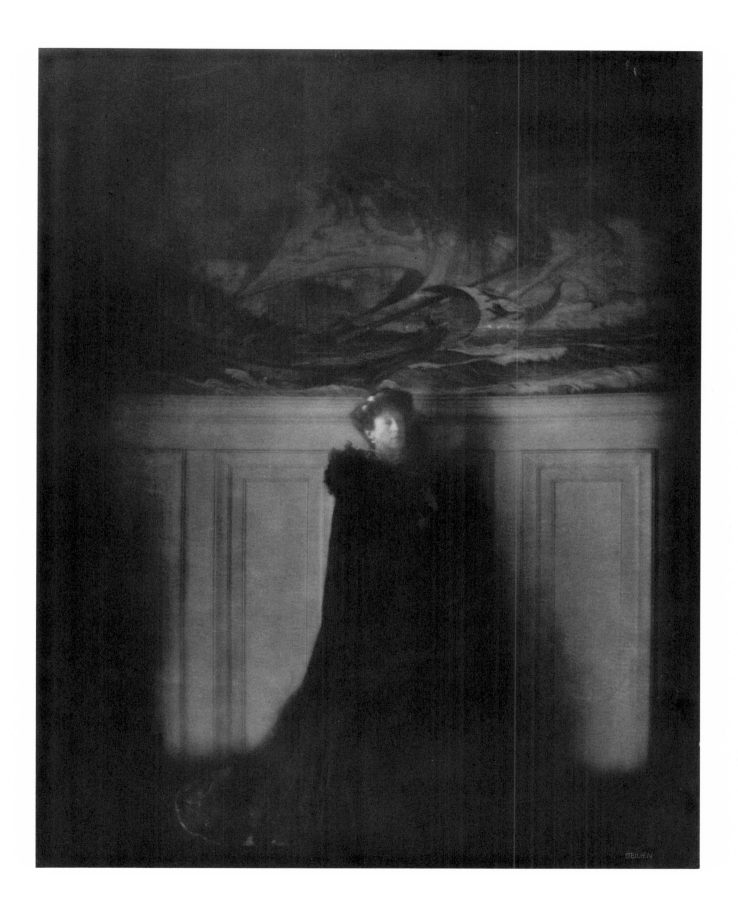

60. ISADORA DUNCAN. C. 1910

Isadora Duncan (1878–1927) struggled to free the dance from the constraints of outmoded traditions, and her bid for liberty was likened by Stieglitz and other secessionists to their struggle for the acceptance of photography as a valid medium of artistic expression. The critic Charles H. Caffin praised her contributions in *Camera Work*: *A few days ago I saw Miss Isadora Duncan in her dance interpretive of Beethoven's Seventh Symphony, which Wagner described as "An Apotheosis of the Dance."* . . .

If you have seen her dance, I wonder whether you do not agree with me that it was one of the loveliest expressions of beauty one has ever experienced. In contrast with the vastness of the Metropolitan Opera House and the bigness of the stage her figure appeared small, and distance lent it additional aloofness. The Personality of the woman was lost in the impersonality of her art. The figure became a symbol of the abstract conception of rhythm and melody. The spirit of rhythm and melody by some miracle seemed to have been made visible. . . .

The movement of beauty that artists of all ages have dreamed of as penetrating the universe through all eternity, in a few moments of intense consciousness, seemed to be realized before one's eyes. It was a revelation of beauty so exquisite, that it brought happy, cleansing tears. Brava, Isadora!

Charles H. Caffin, "Henri Matisse and Isadora Duncan," *Camera Work* (New York), no. 25 (January 1909), pp. 18–19.

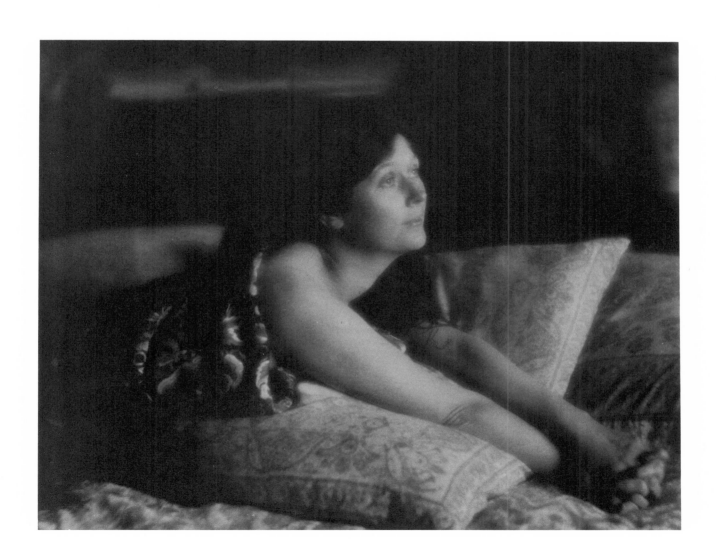

61. EDWARD GORDON CRAIG. 1909

E. Gordon Craig (1872–1966), the son of the celebrated actress Ellen Terry, was himself an actor, stage designer, and theoretician of greatest importance in the decade prior to World War I. It was at this time that his liaison with the dancer Isadora Duncan was most intense. This portrait dates from 1909, the year before Steichen assembled a group of Craig's drawings and etchings for an exhibition at Stieglitz's "291" from December 10, 1910, through January 8, 1911.

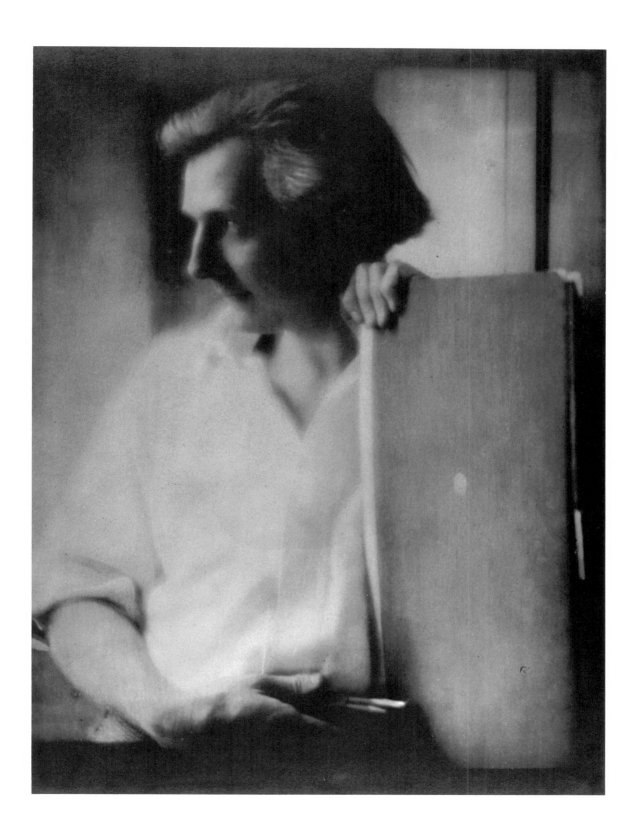

62. MATISSE—LA SERPENTINE. C. 1910

American Art Association of Paris
74, Rue Notre Dame des Champs
Paris [undated, probably 1908]

My dear A[lfred] S[tieglitz]—

I have another cracker jack exhibition for you that is going to be
as fine in its way as the Rodins are. Drawings by Henri Matisse[—]
the most modern of the moderns—his drawings are the same to him
& his painting as Rodin's are to his sculpture. . . . I don't know if
you will remember any of his paintings at Bernheims—Well they
are to the figure what the Cézannes are to the landscape—Simply
great. . . .

Leaf 342, Beinecke.

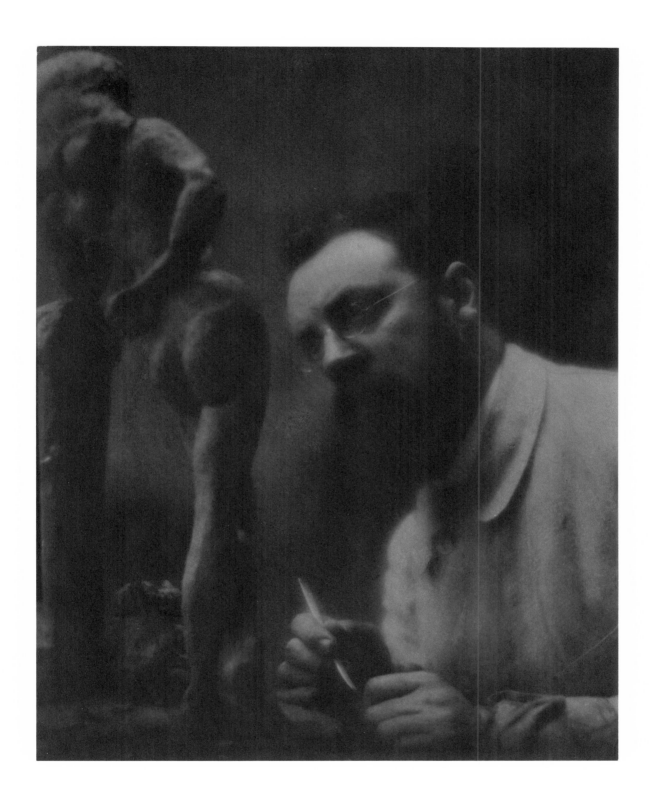

63. ANATOLE FRANCE. c. 1910

Anatole France was the nom de plume of the French novelist Jacques Anatole Thibaut (1844–1924). He was awarded the Nobel Prize for Literature in 1921.

Steichen himself appears briefly in a *roman à clef* published in 1910, shortly after he had successfully shown thirty-one paintings and twenty-eight photographs at the prestigious Montross Gallery on Fifth Avenue in New York. The hero of the work is an impoverished painter, based on the life of artist Max Weber who, by this time, had come to dislike Steichen, or "Stecker," as he is called here. Finch is the author's name for Stieglitz.

Stecker had succeeded in hitting the town at the Montrose Gallery, because Stecker knew the ropes. Stecker was a better business man than he was an artist. He had gone back to Paris now, to his little cottage embowered in roses, where his wife had been waiting for him during the three months of his stay in New York, and had taken with him eight thousand American dollars! No, he did not envy him. Stecker was a fine fellow and meant well. He deserved his success. Still, he was not the big man Finch thought him. He was in the swim, with the rest. . . . He was shrewd, very clever and facile as a colorist; a hard worker, and an excellent talker; but an artist! Weaver shrugged his shoulders. He knew how to advertise. If the critics of the newspapers had sneered, they had not ignored him. And to be talked about in any way, means publicity, and publicity may become a road to success. . . .

Temple Scott [T. H. Isaacs], "Fifth Avenue and the Boulevard Saint-Michel," *The Forum* (New York), vol. 44 (December 1910), pp. 668–69. This work forms a chapter in Scott's book, *The Silver Age and Other Dramatic Memories* (New York: Scott and Seltzer, 1919).

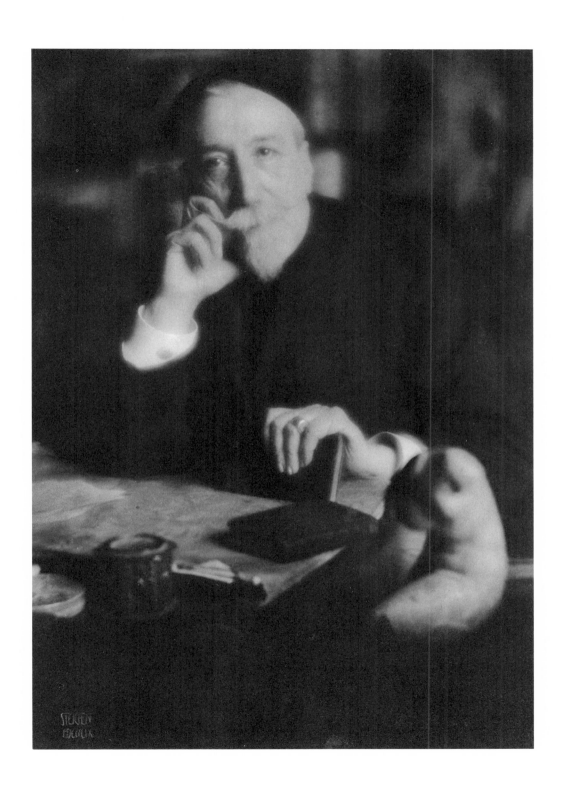

64. JOHN MARIN. NEW YORK. 1911.
Photograph by Steichen and Stieglitz

Collaborative works are comparatively rare but not unknown in the history of photography. Hill and Adamson and Southworth and Hawes in the nineteenth century, Hilla and Bernd Becher in the twentieth come to mind. Stieglitz worked collaboratively with Joseph T. Keiley and, later, with Clarence H. White. This is the only known work by Steichen and Stieglitz.

The subject, the American painter John Marin, was close to both photographers. Stieglitz showed Marin's paintings throughout his career. It was Steichen who introduced them. In a letter, probably written in 1908, he wrote: *I have one show other than the Balzac I will send and that in a week or two [—] Some water colors by John Marin—a young American—ask Caffin about them —They are the real article—*

Leaf 118, Beinecke.

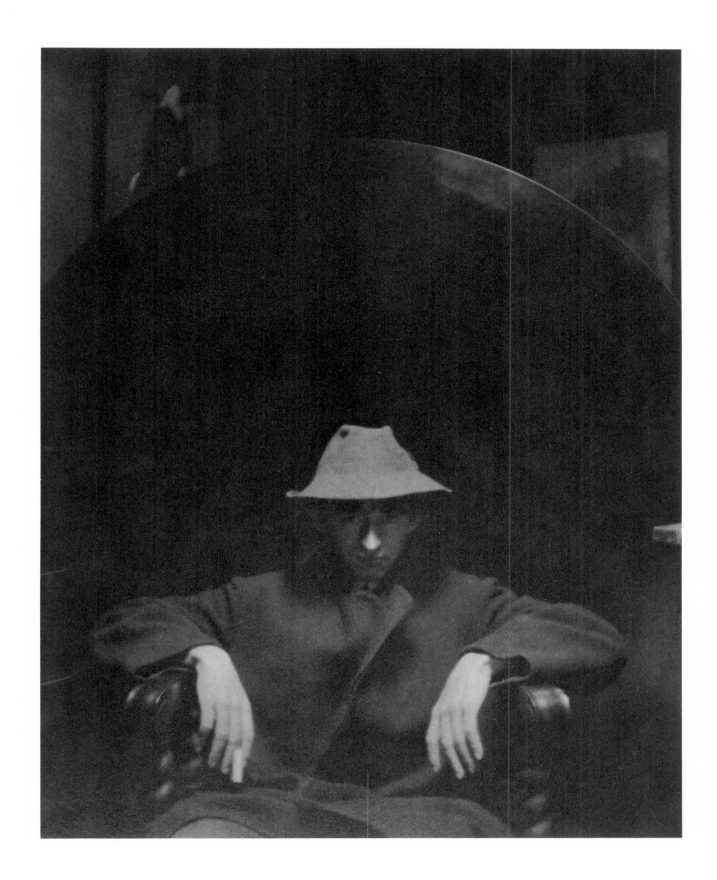

65. Alfred Stieglitz. c. 1909

Stieglitz, then, recognizing the unusualness of Steichen's talent, reasoned that, if this young man lived up to his ideals, he was bound to make a mark: that, if he should succeed in becoming an expert proficient both in photography and in painting, using the one or the other according to its better fitness to express what for the time being he had in mind, the claim that photography may be a medium of artistic expression would have to be admitted. It was to establish this claim, to encourage the photographers to justify it, and the public to recognize it, that he had been fighting for seventeen years. Now was the chance. If Steichen should make good his dual intention, the fight would be won. Thus began the friendship between the older and the younger man, based upon their common belief in photography. . . .

Charles H. Caffin, "Progress in Photography (With Special Reference to the Work of Eduard J. Steichen)," *The Century Magazine* (New York), vol. LXXV, no. 4 (February 1908), p. 491.

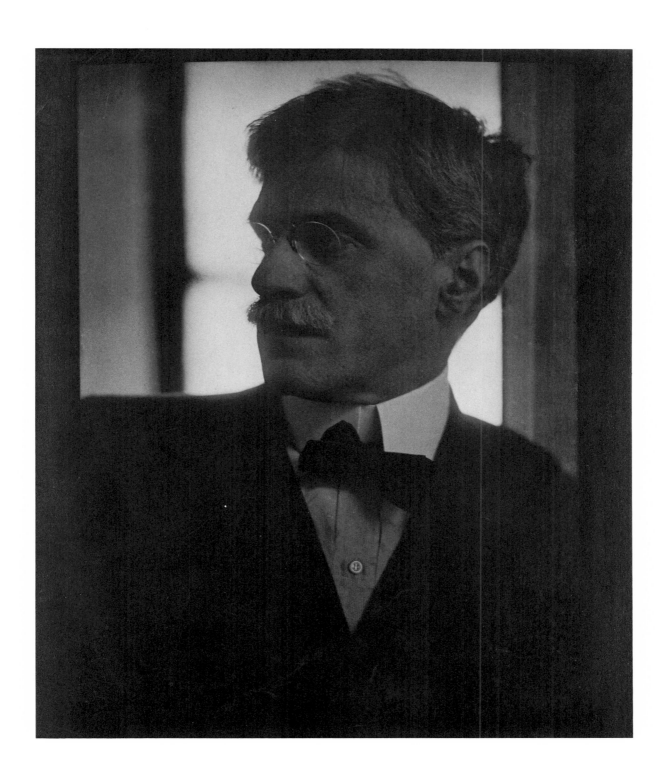

66. MIDNIGHT—RODIN'S BALZAC. MEUDON. 1908

Steichen wrote two letters to Stieglitz in the fall of 1908.

Been photographing & painting Rodin's "Balzac"—he moved it out in the open air and I have been doing it by moonlight—*spent two whole nights—from sunset to sunrise—it was* great—*It is a commission from himself.*

 ⁂

But the Balzacs—I wonder how they will strike you & Caffin— They are the only things I have done of recent that I myself can feel enthusiastic over—And they simply have hit everybody that has seen them here square between the eyes. . . . I hope you can give them a show to themselves if only for a week—The three big ones are a series and should be hung on one wall—The rest anyway you choose. . . .

Leaves 334 and 135, Beinecke.

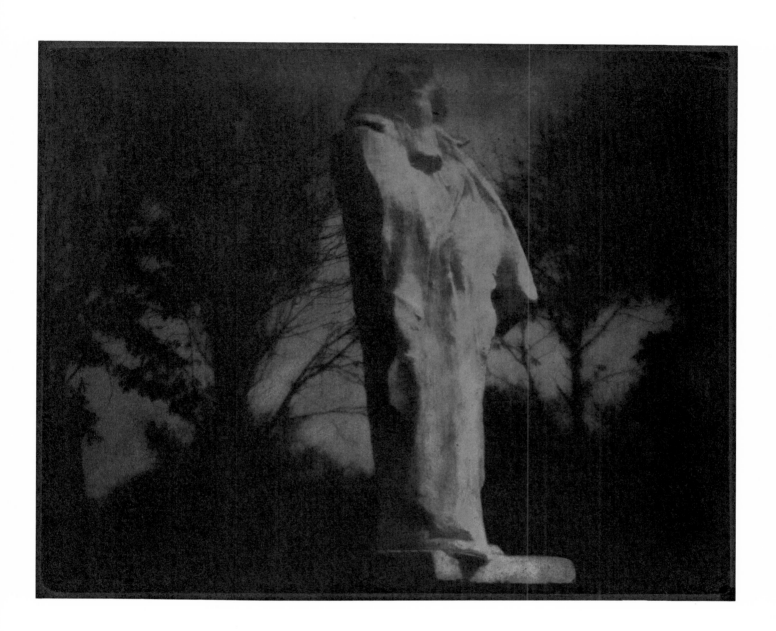

67. THE OPEN SKY, 11 P.M.—RODIN'S BALZAC. MEUDON. 1909 (negative 1908)

The Spirit is outside in the moonlight and the night. For a moment, in the exultation of its disembodied liberty, it halts beside the trees; the branches forming an interlace of blackness around the illumined head. For the moonlight is full upon the proud head: lambent on its lion's mane of hair, on the smooth high forehead, the arched nostrils and curling upper lip. Only the eyes are plunged in the depths of introspective mystery. Robed in shadow also is the form; rearing up like the swell of a wave, luminous upon the arch of its breast.

Charles H. Caffin, "Prints by Eduard J. Steichen—of Rodin's 'Balzac,'" *Camera Work* (New York), no. 28 (October 1909), p. 25.

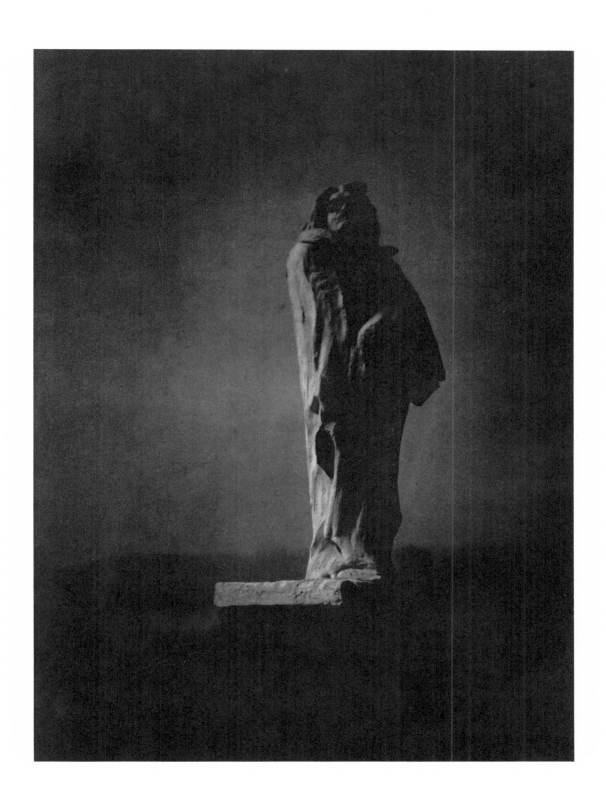

68. Rodin's Balzac. Meudon. 1908

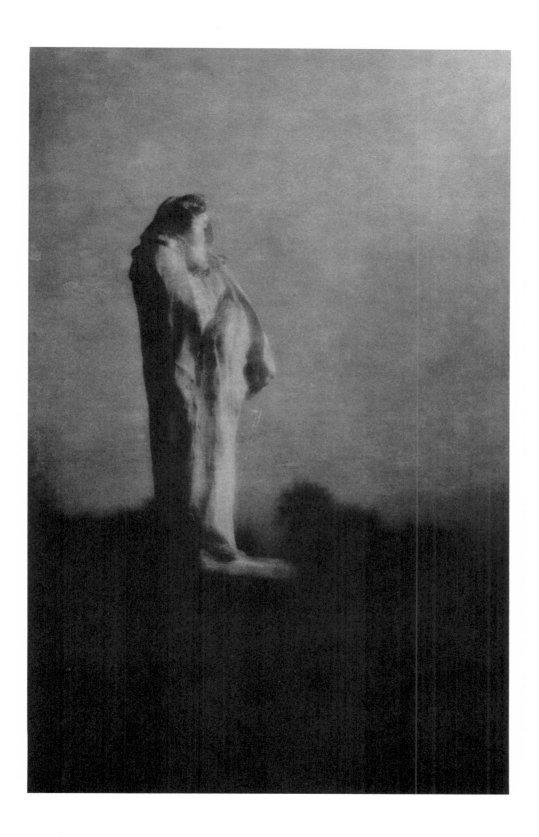

69. Towards the Light, Midnight— Rodin's Balzac. Meudon. 1908

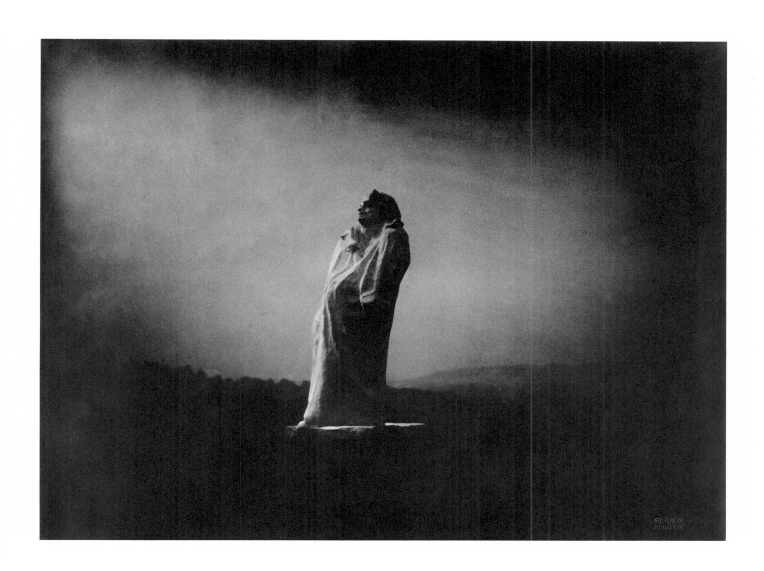

70. The Silhouette, 4 a.m. — Rodin's Balzac. Meudon. 1908

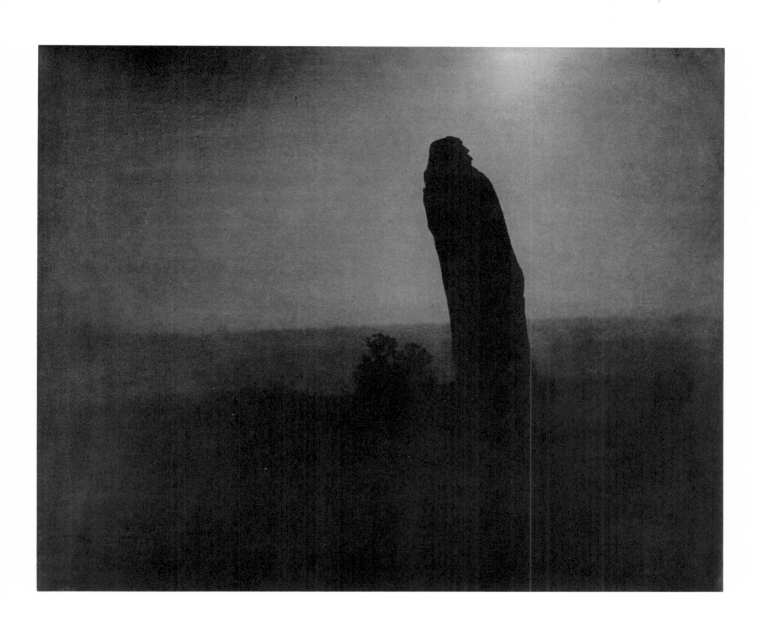

71. Nocturne—Orangerie Staircase,
Versailles. c. 1910

*When Stieglitz saw a set of the Balzac prints later, he seemed more
impressed than with any other prints I had ever shown him. He
purchased them at once and later presented them to the Metro-
politan Museum of Art with most of the other prints of mine that he
had acquired by purchase over a number of years. This collection
not only represents the major part of the good prints I made during
the early periods, but also contains the only surviving record of most
of my early work. During World War I, we had to leave my
negatives behind, uncared for, in our home in Voulangis [in France]
when we left. During the four years of the war, humidity and
bacterial action destroyed the emulsions. The plates were ruined.*

Edward Steichen, *A Life in Photography* (Garden City, N.Y.:
Doubleday & Co., 1963), unpaged (Chapter 4).

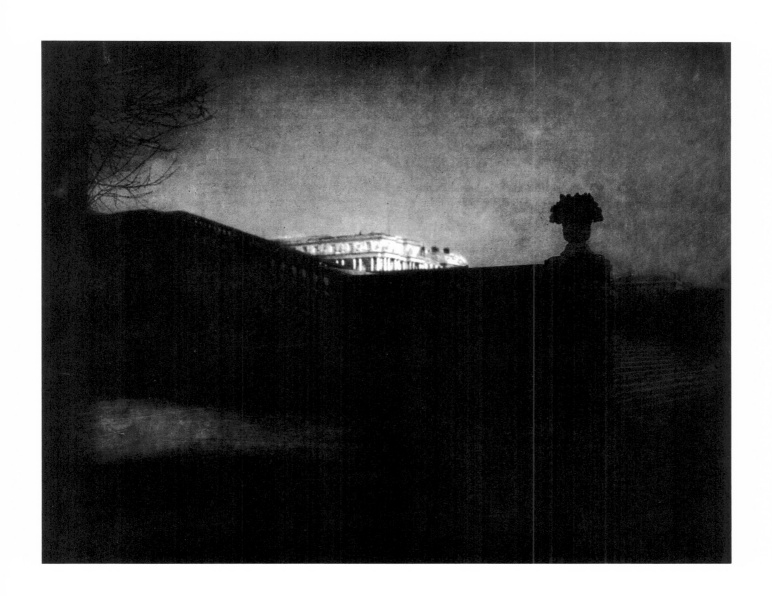

72. HEAVY ROSES. VOULANGIS, FRANCE. 1914

In August 1914 Germany invaded France and World War I began.

Paris—Sept. 2, 1914

Dear Stieglitz—

We are leaving Paris for Marseilles tonight in a cattle train with the other emigrants— We have passage for N.Y. from Marseilles Sept. 10—I don't know even now if we will get out for in view of the fact that all able bodied men young & old are mobilized the rest of the population is weak & panicky—and the rumors are of all kinds— some that the Germans are within 30 kilometers of Paris— The bombs from Aeroplanes do not seem to scare anyone as yet. . . . We are cheerful & hopeful—and not as nervous as we were at the beginning.

<div align="right">

Love to all—

Steichen

</div>

Leaf 175, Beinecke.

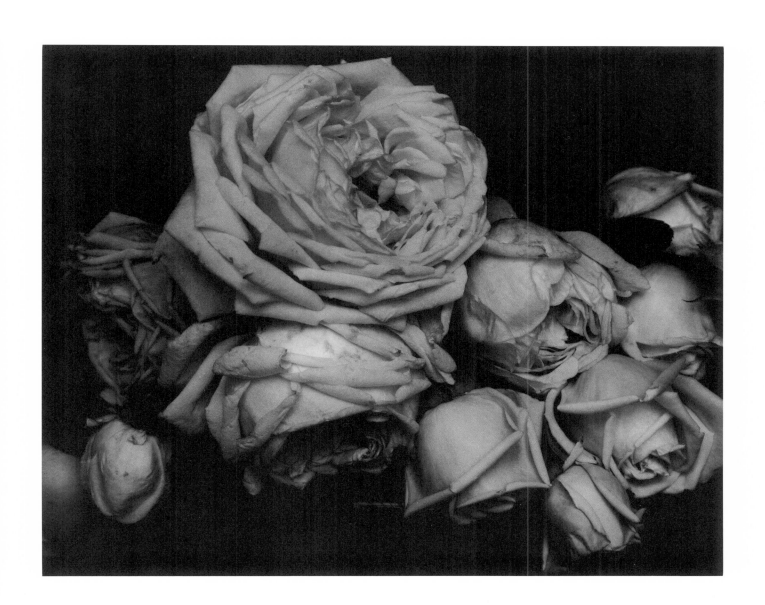

CATALOG OF PLATES

The plates in this book were made directly from Steichen's original prints, with the exceptions of numbers 13, 15, 46, 63, 64, and 67, which were reproduced from the highest quality copy prints, and the six works in color, which were printed from Kodachrome transparencies. Works that are larger than the format of this book have, of course, had to be reduced in reproduction, but those that are smaller than the page are printed in their exact size. The descriptions of the processes used by Steichen are those of the author. Dates in parentheses do not appear on the prints themselves. In some instances Steichen printed from an earlier negative; if known, the dates of the print and the negative both appear. Dimensions are given in inches and centimeters, height preceding width. For works in public collections, the accession number follows the museum's name.

Frontispiece. *Young Girl Standing beside a Vase of Daffodils.* (c. 1908). Unsigned. Autochrome, 6$\frac{1}{2}$ x 4$\frac{1}{2}$ inches (16.5 x 11.4 cm). The Philadelphia Museum of Art. Gift of Miss Mary Talbot. 48.77.2.

1. *Self-Portrait. Milwaukee.* (1898). Unsigned. Platinum print, 7$\frac{13}{16}$ x 3$\frac{5}{8}$ inches (19.8 x 9.2 cm). The Metropolitan Museum of Art, New York. The Alfred Stieglitz Collection. 33.43.1.

2. *Lady in the Doorway. Milwaukee.* (1898). Initialed in ink at lower right. Silver print, 10$\frac{3}{8}$ x 12$\frac{5}{8}$ inches (26.5 x 32.2 cm). The Museum of Modern Art, New York. Gift of the photographer. 141.61.

3. *Woods—Twilight.* (1898). Unsigned. Platinum print, 6 x 8 inches (15.2 x 20 cm). The Metropolitan Museum of Art, New York. The Alfred Stieglitz Collection. 33.43.14.

4. *The Pool—Evening. Milwaukee.* (1899). Unsigned. Platinum print, 8 x 6$\frac{3}{8}$ inches (20.3 x 16.2 cm). The Metropolitan Museum of Art, New York. The Alfred Stieglitz Collection. 49.55.232.

5. *Woods in Rain. Milwaukee.* (1898). Unsigned. Platinum print, 7$\frac{1}{2}$ x 6$\frac{1}{8}$ inches (19 x 15.5 cm). The Metropolitan Museum of Art, New York. The Alfred Stieglitz Collection. 33.43.8. *Note*: also called *Woods Interior.*

6. *Wood Lot—Fallen Leaves.* (1898). Unsigned. Platinum print, 6$\frac{1}{2}$ x 8$\frac{1}{8}$ inches (16.5 x 20.5 cm). The Museum of Modern Art, New York. Gift of the photographer. 21.70.

7. *Farmer's Wood Lot. Milwaukee.* (1898). Unsigned. Platinum print, 7$\frac{1}{2}$ x 5$\frac{7}{8}$ inches. (18.9 x 14.8 cm). The Museum of Modern Art, New York. Gift of the photographer. 20.70.

8. *Self-Portrait with Sister. Milwaukee.* 1900. Unsigned but dated on verso of original mat. Platinum print, 3$\frac{15}{16}$ x 5$\frac{3}{16}$ inches (10 x 13.6 cm). The Museum of Modern Art, New York. Gift of the photographer. 146.61.

9. *Bartholomé.* (1901). Unsigned. Silver print (?), 10$\frac{1}{2}$ x 7$\frac{7}{8}$ inches (26.7 x 20 cm). The Metropolitan Museum of Art, New York. The Alfred Stieglitz Collection. 33.43.16.

10. *Edmond Joseph Charles Meunier. Paris.* (1907). Unsigned. Silver print (?), 14$\frac{1}{8}$ x 10$\frac{1}{4}$ inches (35.9 x 26 cm). The Metropolitan Museum of Art, New York. The Alfred Stieglitz Collection. 33.43.11.

11. *Rodin—Le Penseur.* 1902. Signed and dated lower left. Gum-bichromate print, 15$\frac{7}{8}$ x 19$\frac{13}{16}$ inches (40.3 x 50.3 cm). Collection Caroline Hammarskiöld, Djursholm, Sweden.

12. *Alphonse-Marie Mucha. Paris.* 1902. Signed and dated in nega-tive. Signed in ink on mount. Platinum print, 10$\frac{3}{4}$ x 8$\frac{3}{8}$ inches (27.3 x 21.3 cm). The Philadelphia Museum of Art. Gift of Christian Brinton. 41.79.43.

13. *Self-Portrait with Brush and Palette. Paris.* 1902 (negative 1901). Signed and dated lower left in white pencil. Gum-bichromate print, 11 x 7$\frac{7}{8}$ inches (27.6 x 20 cm). The Art Institute of Chicago. The Alfred Stieglitz Collection. 49.823. *Note*: also called *Self-Portrait.*

14. *George Frederic Watts.* (1901). Signed lower left in pencil; titled in pencil across top. Gum-bichromate print, 13$\frac{5}{16}$ x 10$\frac{3}{8}$ inches (33.8 x 26.4 cm). The Metropolitan Museum of Art, New York. The Alfred Stieglitz Collection. 33.43.26.

15. *Frederick H. Evans.* (1900). Signed in Evans's hand "Steichen." Platinum print, 7$\frac{5}{8}$ x 4$\frac{3}{8}$ inches (19.4 x 11.1 cm). The Metropolitan Museum of Art, New York. David Hunter McAlpin Fund. 68.688.4.

16. *The Black Vase.* 1901. Signed and dated lower left. Gum-bichromate print (?), 8$\frac{1}{16}$ x 6$\frac{1}{16}$ inches (20.4 x 15.4 cm). The Metropolitan Museum of Art, New York. The Alfred Stieglitz Collection. 33.45.20. *Note*: also called *Woman beside a Window.*

17. *The Mirror.* 1901. Signed with monogram "S" and drawing of a rose and dated in pencil on front of original mat. Platinum print, 8 x 6 inches (20.2 x 15.2 cm). Collection Mr. and Mrs. Noel Levine, New York.

18. *The Cat.* (1902). Unsigned. Platinum print, 8 x 6 inches (20.2 x 15.2 cm). Collection Mr. and Mrs. Noel Levine, New York.

19. *La Cigale.* (1907 print from 1901 negative). Signed in pencil. Gum-bichromate over platinum print, 10$\frac{3}{8}$ x 11$\frac{3}{8}$ inches (26.4 x 28.9 cm). The Metropolitan Museum of Art, New York. The Alfred Stieglitz Collection. 33.43.22.

20. *Figure with Iris.* 1902. Signed and dated in ink. Gum-bichromate print, 13$\frac{3}{8}$ x 7$\frac{7}{16}$ inches (34 x 19 cm). The Metropolitan Museum of Art, New York. The Alfred Stieglitz Collection. 33.43.17.

21. *Little Round Mirror. Paris.* 1902 (negative 1901). Signed and dated upper right. Gum-bichromate over platinum print, 19$\frac{1}{8}$ x 13$\frac{1}{16}$ inches (48.6 x 33.2 cm). The Metropolitan Museum of Art, New York. The Alfred Stieglitz Collection. 33.43.32.

22. *In Memoriam. New York.* 1905. Signed and dated upper right. Silver print (?), 19 x 14$\frac{1}{4}$ inches (48.5 x 36.2 cm). The Museum of Modern Art, New York. Gift of the photographer. 362.64.

23. *Otto, French Photographer.* (c. 1902). Unsigned. Gum-bichromate print, 8$\frac{1}{16}$ x 5$\frac{3}{4}$ inches (20.4 x 14.6 cm). The Metropolitan Museum of Art, New York. The Alfred Stieglitz Collection. 49.55.231.

24. *Maurice Maeterlinck. Paris.* (1901). Signed in pencil lower right. Gum-bichromate print, 13$\frac{1}{8}$ x 10$\frac{1}{2}$ inches (33.3 x 26.7 cm). The Metropolitan Museum of Art. The Alfred Stieglitz Collection. 33.43.2.

25. *Franz von Lenbach. Munich.* 1903 (negative 1901). Signed and dated in yellow crayon pencil lower left. Gum-bichromate print, 20$\frac{1}{4}$ x 14$\frac{5}{8}$ inches (51.5 x 37.2 cm). The Metropolitan Museum of Art, New York. The Alfred Stieglitz Collection. 33.43.33.

26. *J. P. Morgan. New York.* 1904 (negative 1903). Signed and dated in pencil lower right. Silver bromide print, 20$\frac{1}{4}$ x 16 inches (51.5 x 40.7 cm). The Metropolitan Museum of Art, New York. The Alfred Stieglitz Collection. 49.55.167.

27. *Clarence H. White.* (1903). Unsigned. Platinum print, 13³/₈ x 10¹/₈ inches (34 x 25.7 cm). The Museum of Modern Art, New York. Gift of Mr. and Mrs. Clarence H. White, Jr. 75.76.

28. *The Brass Bowl.* 1904. Signed and dated in pencil lower left. Gum-bichromate print, 12 x 10¹/₈ inches (30.5 x 25.8 cm). The Metropolitan Museum of Art, New York. The Alfred Stieglitz Collection. 33.43.6.

29. *Mercedes de Cordoba Carles. New York.* 1904. Signed and dated in pencil lower left. Gum-bichromate print, 12³/₈ x 10¹/₈ inches (31.5 x 25.8 cm). The Metropolitan Museum of Art, New York. The Alfred Stieglitz Collection. 33.43.3.

30. *Experiment in Multiple Gum.* 1904. Signed and dated in ink on gray submount. Gum-bichromate print, 11¹/₈ x 9¹/₂ inches (28.3 x 24.2 cm). The Metropolitan Museum of Art, New York. The Alfred Stieglitz Collection. 33.43.13.

31. *Winter Landscape. Lake George.* (1904–05). Unsigned. Multiple-gum-bichromate print, 2¹³/₁₆ x 3¹/₈ inches (7.2 x 8 cm). The Museum of Modern Art, New York. Gift of the photographer. 149.61.

32. *Moonlight—Winter.* 1902. Signed and dated in green pencil lower left. Platinum and gum-bichromate print, 13⁵/₈ x 16⁷/₈ inches (34.6 x 42.9 cm). The Metropolitan Museum of Art, New York. The Alfred Stieglitz Collection. 33.43.30.

33. *The Big White Cloud. Lake George, New York.* (1903. Dated 1902 on print). Signed and dated in yellow pencil lower left. Platinum, cyanotype, and gum-bichromate print, 15⁷/₁₆ x 19 inches (40.4 x 48.3 cm). The Metropolitan Museum of Art, New York. The Alfred Stieglitz Collection. 33.43.47.

34. *Garden of the Gods, Colorado.* 1906. Signed and dated in yellow crayon pencil. Gum-bichromate print, 15⁵/₁₆ x 18⁵/₁₆ inches (38.9 x 46.5 cm). The Metropolitan Museum of Art, New York. The Alfred Stieglitz Collection. 33.43.25.

35. *Moonrise. Mamaroneck, New York.* 1904. Signed and dated lower right. Platinum and ferroprussiate print. The Museum of Modern Art, New York. Gift of the photographer. 364.68.

36. *Steichen and Wife Clara on Their Honeymoon. Lake George, New York.* (1903). Unsigned. Platinum print, 11³/₄ x 15¹³/₁₆ inches (29.9 x 40.2 cm). The Museum of Modern Art, New York. Gift of Mary Steichen Calderone, M.D. 85.73.

37. *Horse Chestnut Trees. Long Island.* 1905 (negative 1904). Signed and dated in pencil lower right. Gum-bichromate over platinum print, 19¹/₂ x 15³/₄ inches (49.6 x 40 cm). The Metropolitan Museum of Art, New York. The Alfred Stieglitz Collection. 33.43.42.

38. *Mary Steichen and Her Mother. Huntington, L.I.* (1905–06). Unsigned. Platinum print, 6⁵/₁₆ x 14¹¹/₁₆ inches (16 x 37.3 cm). The Museum of Modern Art, New York. Gift of Mary Steichen Calderone, M.D. 73.73.

39. *Mary and Her Mother. Long Island.* 1905. Signed and dated lower right in yellow pencil. Silver print, 13¹¹/₁₆ x 10¹³/₁₆ inches (34.8 x 27.5 cm). The Metropolitan Museum of Art, New York. The Alfred Stieglitz Collection. 33.43.27.

40. *Mrs. Stieglitz and Her Daughter.* (1904. Dated 1903 on print). Signed and dated in pencil lower right. Platinum or silver print, 19¹/₂ x 15¹/₄ inches (49.6 x 38.8 cm). The Metropolitan Museum of Art, New York. The Alfred Stieglitz Collection. 33.43.28. *Note*: Stieglitz dated this photograph 1904.

41. *Alfred Stieglitz and Kitty. New York.* 1905 (negative 1904). Signed and dated upper left in ink. Gum-bichromate print, 17³/₄ x 15³/₄ inches (45.1 x 40 cm). The Metropolitan Museum of Art, New York. The Alfred Stieglitz Collection. 33.43.23.

42. *Alfred Stieglitz and Kitty. New York.* 1905 (negative 1904). Signed and dated in pencil lower right. Platinum print, 9³/₄ x 9³/₁₆ inches (24.7 x 23.3 cm). The Metropolitan Museum of Art, New York. The Alfred Stieglitz Collection. 49.55.228.

43. *Alfred Stieglitz and Kitty. New York.* 1905 (negative 1904). Unsigned. Platinum print, 11³/₈ x 9³/₈ inches. The Metropolitan Museum of Art, New York. The Alfred Stieglitz Collection. 49.55.230.

44. *Sadakichi Hartmann.* 1903. Signed and dated in orange pencil lower right. Gum-bichromate print, 9¹¹/₁₆ x 12 inches (24.6 x 30.5 cm). The Metropolitan Museum of Art, New York. The Alfred Stieglitz Collection. 33.43.52.

45. *Richard Strauss. New York.* 1906 (negative 1904). Signed and dated lower left. Gum-bichromate print, 18¹/₂ x 13 inches (47 x 33 cm). The Metropolitan Museum of Art, New York. The Alfred Stieglitz Collection. 49.55.168.

46. *Rodin. Paris.* 1907. Signed and dated in pencil lower left. Toned silver print, 12¹/₄ x 11¹/₄ inches (39.1 x 28.6 cm). The Art Institute of Chicago. The Alfred Stieglitz Collection. 49.826.

47. *Agnes Ernst Meyer.* (1906–08). Signed in negative. Platinum print, 10⁵/₈ x 8¹¹/₁₆ inches (21.9 x 27.3 cm). The Metropolitan Museum of Art, New York. The Alfred Stieglitz Collection. 49.55.226.

48. *The Photographer's Best Model: George Bernard Shaw. London.* 1907. Signed and dated in yellow pencil lower left. Platinum print, 19³/₄ x 15¹/₈ inches (49.3 x 38.5 cm). The Metropolitan Museum of Art, New York. The Alfred Stieglitz Collection. 49.55.166.

49. *Mrs. Condé Nast. Paris.* 1907. Signed and dated in pencil. Platinum and gum-bichromate print, 10¹¹/₁₆ x 8¹⁵/₁₆ inches (27.1 x 22.7 cm). The Museum of Modern Art, New York. Gift of Mrs. Condé Nast. 376.55.

50. *Cyclamen—Mrs. Philip Lydig. New York.* (c. 1905). Unsigned. Gum-bichromate print, 12⁷/₁₆ x 8¹/₂ inches (31.5 x 21.6 cm). The Metropolitan Museum of Art, New York. The Alfred Stieglitz Collection. 33.43.9.

51. *Lillian Steichen. Menominee Falls, Wisconsin.* (1907). Unsigned. Platinum and gum-bichromate print, 9¹¹/₁₆ x 9³/₈ inches (24.7 x 24 cm). The Museum of Modern Art, New York. Gift of the photographer. 363.64.

52. *Portrait of My Mother. Milwaukee.* (1908). Unsigned. Platinum print, 7⁵/₈ x 4⁵/₈ inches (19.4 x 11.8 cm). The Museum of Modern Art, New York. Gift of the photographer. 36.70.

53. *French Peasant Woman.* (c. 1907). Unsigned. Platinum print, 8¹/₈ x 6¹/₈ inches (20.5 x 15.5 cm). The Museum of Modern Art, New York. Gift of the photographer. 17.70.

54. *Steeplechase Day, Paris: After the Races.* (1907). Unsigned. Gum-bichromate print, 10⁵/₈ x 11⁵/₈ inches (27 x 29.6 cm). The Metropolitan Museum of Art, New York. The Alfred Stieglitz Collection. 33.43.51.

55. *Steeplechase Day, Paris: Grandstand.* (1907). Signed in pencil lower right. Gum-bichromate print, 10³/₄ x 13⁷/₈ inches (27.4 x 35.3 cm). The Metropolitan Museum of Art, New York. The Alfred Stieglitz Collection. 33.43.49.

56. *The Flatiron.* (1905). Unsigned. Gum-bichromate over platinum print, 18³/₄ x 15¹/₈ inches (47.8 x 38.4 cm). The Metropolitan Museum of Art, New York. The Alfred Stieglitz Collection. 33.43.43.

57. *Mrs. Eugene Meyer. New York.* 1910. Signed and dated upper left in ink. Gum-bichromate print, 11 x 8³/₄ inches (28 x 22.2 cm). The Museum of Modern Art, New York. Gift of the photographer. 185.64.

58. *Landon Rives—Melpomene.* 1903. Signed and dated lower right. Gum-bichromate over platinum print, 18³/₄ x 12³/₄ inches (47.7 x 32.4 cm). The Metropolitan Museum of Art, New York. The Alfred Stieglitz Collection. 33.43.31.

59. *Lady Ian Hamilton. London.* (1907). Signed in pencil lower right. Gum-bichromate over platinum print, 19⁷/₈ x 15⁹/₁₆ inches (50.5 x 39.5 cm). The Metropolitan Museum of Art, New York. The Alfred Stieglitz Collection. 33.43.24.

60. *Isadora Duncan.* (c. 1910). Unsigned. Platinum print, 7⁷/₈ x 9⁷/₈ inches (19.9 x 25 cm). The Museum of Modern Art, New York. Gift of the photographer. 15.70.

61. *Edward Gordon Craig.* (1909). Unsigned. Silver print, 19¹/₈ x 14¹/₈ inches (48 x 35.9 cm). The Metropolitan Museum of Art, New York. The Alfred Stieglitz Collection. 49.55.227.

62. *Matisse—La Serpentine.* (c. 1910). Unsigned. Platinum print, 11⁵/₈ x 9³/₁₆ inches (29.6 x 23.4 cm). The Museum of Modern Art, New York. Gift of the photographer. 270.61.

63. *Anatole France.* (c. 1910). Unsigned. Platinum print, 12⁷/₈ x 7¹/₈ inches (32.7 x 18 cm). Victoria and Albert Museum, London.

64. *John Marin. New York.* (1911). Unsigned. Photograph by both Stieglitz and Steichen; platinum print by Stieglitz. 9⁷/₁₆ x 7³/₁₆ inches (24 x 18.3 cm). The Art Institute of Chicago. The Alfred Stieglitz Collection. 49.712.

65. *Alfred Stieglitz.* (c. 1909). Unsigned. Platinum print, 11⁵/₈ x 9⁹/₁₆ inches (29.5 x 24.3 cm). The Museum of Modern Art, New York. Gift of the photographer. 1228.64.

66. *Midnight—Rodin's Balzac. Meudon.* (1908). Unsigned. Gum-bichromate print, 11¹⁵/₁₆ x 14³/₈ inches (30 x 36.5 cm). The Museum of Modern Art, New York. Gift of the photographer. 196.63.

67. *The Open Sky, 11 P.M.—Rodin's Balzac. Meudon.* 1909 (negative 1908). Signed and dated lower left. Gum-bichromate print, 19³/₁₆ x 15³/₁₆ inches (48.7 x 38.5 cm). The Metropolitan Museum of Art, New York. The Alfred Stieglitz Collection. 33.43.46.

68. *Rodin's Balzac. Meudon.* (1908). Signed in yellow pencil lower right. Gum-bichromate print, 11 x 8¹/₈ inches (28 x 20.7 cm). The Metropolitan Museum of Art, New York. The Alfred Stieglitz Collection. 33.43.5.

69. *Towards the Light, Midnight—Rodin's Balzac. Meudon.* 1908. Signed and dated in yellow pencil lower right. Gum-bichromate print, 14³/₈ x 19 inches (36.5 x 48.3 cm). The Metropolitan Museum of Art, New York. The Alfred Stieglitz Collection. 33.43.38.

70. *The Silhouette, 4 A.M.—Rodin's Balzac. Meudon.* (1908). Signed in yellow pencil lower right. Gum-bichromate print, 14⁷/₈ x 18¹/₁₆ inches (37.8 x 45.9 cm). The Metropolitan Museum of Art, New York. The Alfred Stieglitz Collection. 33.43.36.

71. *Nocturne—Orangerie Staircase, Versailles.* (c. 1910). Signed lower right in pencil. Gum-bichromate print, 11 x 13⁷/₈ inches (28 x 35.5 cm). The Museum of Modern Art, New York. Gift of the photographer. 38.70.

72. *Heavy Roses. Voulangis, France.* (1914). Unsigned. Silver print, 7¹⁵/₁₆ x 9¹⁵/₁₆ inches (20.2 x 25.3 cm). The Museum of Modern Art, New York. Gift of the photographer. 152.61.

STEICHEN'S PRINTING TECHNIQUES

The creative photographer in the first decade of this century had readily available to him an array of printmaking techniques, each offering special characteristics that could express his vision. In this respect, today's photographer seems impoverished. Steichen, a master printer of photographs, relied primarily on the platinum and the gum-bichromate processes and on virtuoso combinations of these two. In addition, his repertoire included at least the following: the conventional silver print (today's basic printmaking medium), the cyanotype (the architect's common "blueprint"—also called in Steichen's time the "ferroprussiate print"), and the autochrome (the first simple, effective process to reproduce the visual world in full color).

The platinum print, or platinotype, invented by William Willis in England in 1873, was made from commercially prepared paper that supported in its fibers a deposit of light-sensitive platinum salts. The photographer's negative was printed by contact in daylight and then developed for about thirty seconds in a solution of potassium oxalate. The print was "cleared" of yellow stain in baths of dilute hydrochloric acid, washed in water for an hour, and then dried. The result was a print with clearly separated blacks and a seemingly infinite range of grays unattainable in any other process. Commercial production of platinum paper ceased about 1930.

The gum-bichromate process, exhibited in London as early as 1858, was simpler, cheaper, and more yielding to the photographer's expressive demands than platinum. It was prepared, on heavily sized paper, in the photographer's own darkroom. Charles H. Caffin, in an important article in *The Century Magazine* in 1908, described Steichen's masterly use of the gum-bichromate process:

> For those who, like myself, are laymen, it may be explained that in this process the photographer sensitized the paper on which he intends to print with a solution of gum arabic, bichromate of potash [potassium bichromate], and a pigment of any color he chooses. Light renders this solution insoluble. Therefore, when the paper is exposed beneath a negative, certain portions of the surface become more or less insoluble, according to the amount of light which they have received. When the negative is removed, the paper presents an undisturbed surface of uniform color; but after it has been subjected to water, the soluble portions begin to dissolve away until a faint image appears. Then, if the photographer is content simply to reproduce the effects and qualities contained in

the negative, he continues the washing until the print is fully developed. But on the other hand, he can, if he desires, introduce into the print effects and qualities that are not in the negative. He can, for example, omit details, reduce the dark parts, change dark into light and vice versa, and graduate his grays, by controlling the application of more or less water to certain parts. He can even alter the drawing in the picture, if he wishes. In fact, the process is so elastic that there is virtually no limit, except that of his own skill and feeling, to the changes and effects he can secure. Steichen, for example, with his command of the process, could take another man's negative and produce from it a print that would be characteristically "a Steichen."[1]

What Caffin does not say is that the gum-bichromate process gave Steichen additional control over the color and richness of the print through double and triple coatings of light-sensitive emulsions. After the first printing was completed and dried, the surface was recoated, dried, registered under the negative, and exposed a second and, possibly, a third time. These additional developments allowed the same measure of control as the first and resulted in a stronger, richer print.

One can attempt to determine visually, through a microscope, which process Steichen employed in making an individual print. Because the gum-bichromate process requires that the paper be sized, the bits of pigment that compose the image appear to rest atop the glistening surface of the paper. In the platinum process, by contrast, the image seems to be *in* the paper, and the fibers making up the paper are clearly visible. Complications arise, however, in those hybrid works that combine the platinum (and perhaps the silver) and gum-bichromate processes. In these, Steichen first made a fairly light print on platinum paper. He then resensitized the print with gum bichromate and allowed it to dry. The print was then registered under the enlarged negative a second time. After exposure to daylight, the print was developed in plain water in the usual way. Similarly, a coating of cyanotype (ferroprussiate) solution, in a process invented by Sir John Herschel in 1842, was added to a number of Steichen's largest and most elaborate works. This solution, in its simplest form, consisted of potassium ferricyanide and ferric ammonium citrate. The prepared paper was registered to the negative, exposed to light until the required depth of tone was achieved, then washed in several changes of water

—the final bath being slightly acidified with hydrochloric acid. The complications inherent in these elaborate, technically demanding processes may partially explain the very small number of Steichen prints that are known to have survived.

The autochrome process was the first practical system of color photography. It was invented by Auguste and Louis Lumière in 1903, but technical problems were not overcome until 1907, when it was released to the public. The process involved coating a glass plate with microscopic particles of starch that had been dyed in the three primary colors. A panchromatic emulsion was applied over this color "screen." After exposure and reversal development, the image viewed through the color "screen" was in full color. Small autochromes could be projected, just as one projects color slides today. Large autochromes were viewed by holding them up to the light, illuminating them from behind, or placing them in a special viewer that permitted light to pass through the glass plate onto a mirror, which reflected the image to the eye. The process was discontinued sometime in the 1930s. That it was extremely beautiful can be noted in the tribute Steichen paid to it in *Camera Work*. He wrote: "Personally I have no medium that can give me color of such wonderful luminosity as the Autochrome plate. One must go to stained glass for such color resonance, as the palette and canvas are a dull and lifeless medium in comparison."[2]

NOTES

1. Charles H. Caffin, "Progress in Photography (With Special Reference to the Work of Eduard J. Steichen)," *The Century Magazine* (New York), vol. 75, no. 4 (February 1908), p. 493.
2. Eduard J. Steichen, "Color Photography," *Camera Work* (New York), no. 22 (April 1908), p. 24.

SELECTED BIBLIOGRAPHY

STEICHEN REPRODUCTIONS

Steichen's photographs were widely reproduced in the period before 1914. The following list includes only those issues containing Steichen reproductions in the magazines edited by Alfred Stieglitz, *Camera Notes* and *Camera Work*. Frequently articles about Steichen and his work accompany the illustrations.

Camera Notes (New York). Vol. 4, no. 3 (January 1901).
 6 ills.
 Vol. 6, no. 1 (July 1902). 14 ills.
Camera Work (New York). No. 2 (April 1903). 11 pls.;
 1 ill. in advertising section.
 No. 7 (July 1904). 1 pl.
 No. 9 (January 1905). 1 pl.
 No. 11 (July 1905). 2 pls.
 No. 13 (January 1906). 1 ill. in advertising section.
 No. 14 (April 1906). 10 pls.
 Special Steichen Supplement (April 1906). 16 pls.
 No. 15 (July 1906). 1 pl.; 1 ill. in advertising section.
 No. 19 (July 1907). 1 pl.
 No. 22 (April 1908). 3 pls.
 No. 34–35 (April–July 1911). 4 pls.
 No. 42–43 (April–July 1913). 17 pls.
 No. 44 (October 1913). 1 pl.

ARTICLES BY STEICHEN, 1900–14

"British Photography from an American Point of View." *The Amateur Photographer* (London), vol. 32, no. 839 (November 2, 1900), pp. 343–45. Reprinted in *Camera Notes*, vol. 4, no. 3 (January 1901), pp. 175–81.

"The American School." *The Photogram* (London), vol. 8, no. 85 (January 1901), pp. 4–9. Reprinted in *Camera Notes*, vol. 6, no. 1 (July 1902), pp. 22–24.

"Ye Fakers." *Camera Work*, no. 1 (January 1903), p. 48.

"Color Photography." *Camera Work*, no. 22 (April 1908), pp. 13–24.

"Painting and Photography." *Camera Work*, no. 23 (July 1908), pp. 3–5. Reprinted in *Academy Notes* (Buffalo), no. 1 (January 1911), pp. 16–18.

"What Is '291'?" *Camera Work*, no. 47 (July 1914), pp. 65–66.

ARTICLES ABOUT STEICHEN

Soulier, Gustave. "L'Art photographique et l'école américaine." *Art et décoration* (Paris), vol. 10, September 1901, pp. 76–80.

Juhl, Ernst. "Eduard J. Steichen." *Photographische Rundschau* (Vienna), vol. 16, no. 7 (July 1902), pp. 127–29.

Anonymous. "Mr. Steichen's Pictures." *The Photographic Journal* (London), vol. 2, no. 14 (April 15, 1902), pp. 25–29.

Yeo, H. Vivian. "The American School and Mr. Steichen's Pictures." *The Amateur Photographer* (London), vol. 35, no. 918 (May 1, 1902), pp. 346–47.

Stieglitz, Alfred. ["Eduard J. Steichen."] *Camera Notes*, vol. 6, no. 1 (July 1902), p. 15.

Brinton, Christian. "Four Portrait-Photographs by Eduard Steichen." *The Critic* (New York), vol. 42, no. 3 (March 1903), pp. 198–99.

Rood, Roland. "Eduard J. Steichen: A Study of the Artistic Attitude toward Art and Nature." *The American Amateur Photographer* (New York), vol. 18, no. 4 (April 1906), pp. 157–62.

Caffin, Charles H. "Progress in Photography (With Special Reference to the Work of Eduard J. Steichen)." *The Century Magazine*, vol. 75, no. 4 (February 1908), pp. 482–98.

Caffin, Charles H. "Prints by Eduard J. Steichen—of Rodin's 'Balzac.'" *Camera Work*, no. 28 (October 1909), p. 25.

Caffin, Charles H. "The Art of Eduard J. Steichen." *Camera Work*, no. 30 (April 1910), pp. 33–36.

Cornu, Paul. "L'Art de la robe." *Art et décoration* (Paris), vol. 29, April 1911, pp. 101–18.

Maeterlinck, Maurice. "Sur la photographie." *Cahiers d'aujourd'hui* (Paris), no. 2, 1912, pp. 53–54.

Strand, Paul. "Steichen and Commercial Art." *The New Republic* (New York), February 19, 1930, p. 21.

Brokaw, Clare Boothe. "Edward Steichen, Photographer." *Vanity Fair* (New York), June 1932, pp. 49, 60, 70.

Harriman, Margaret Case. "Steichen." *Vogue* (New York), January 1, 1938, pp. 36–41, 92, 94.

Josephson, Matthew. "Commander with a Camera." *The*

New Yorker, June 3, 1944, pp. 30–36, and June 10, 1944, pp. 29–41.

Cisney, Lenore, and Reddy, John. "Edward Steichen: Dissatisfied Genius." *Saturday Review* (New York), December 14, 1957, pp. 9–12.

Millstein, Gilbert. "'De Lawd' of Modern Photography." *New York Times Magazine*, March 22, 1959, pp. 22–23.

Liberman, Alexander. "Steichen's Eye: A Study of the Greatest Living Photographer." *Vogue* (New York), August 1, 1959, pp. 94–99, 140, 142.

Norman, Dorothy. "Alfred Stieglitz." *Aperture* (Rochester), vol. 8, no. 1, 1960, pp. 18–20.

Geldzahler, Henry. "Edward Steichen: The Influence of a Camera." *Art News* (New York), vol. 60, no. 3 (May 1961), pp. 26–28, 52–53.

Greenberg, Clement. "Four Photographers." *New York Review of Books*, January 23, 1964, pp. 8–9.

Sekula, Allan. "The Instrumental Image: Steichen at War." *Artforum* (New York), vol. 14, no. 4 (December 1975), pp. 26–35.

EXHIBITION CATALOGS

Royal Photographic Society. *An Exhibition of Prints by the New School of American Photography*. London: October 10–November 8, 1900.

Photo-Club de Paris. *Catalogue des oeuvres de F. Holland Day et de la nouvelle école américaine*. Paris: February 22–March 10, 1901. Presents an expanded version of the exhibition indicated in preceding entry.

Maison des Artistes. [*Eduard J. Steichen . . . Exposition.*] Paris: June 3–24, 1902.

Juhl, Ernst. *Camera-Kunst, eine Internationale Sammlung von Kunst-Photographien der Neuzeit*. Berlin: Gustav Schmidt, 1903.

Montross Gallery. *Exhibition of Pictures by Eduard J. Steichen*. New York: January 17–29, 1910.

Knoedler & Co. *Paintings by Eduard J. Steichen*. New York: January 25–February 6, 1915.

Baltimore Museum of Art. *Edward Steichen: A Retrospective Exhibition*. Baltimore: June 1–30, 1938.

The Museum of Modern Art. *Steichen the Photographer*. With essays by Carl Sandburg, Alexander Liberman, Edward Steichen, and René d'Harnoncourt; biographical outline by Grace M. Mayer. Garden City, N.Y.: Doubleday & Co., 1961.

BOOKS ON STEICHEN, STIEGLITZ, AND THE PHOTO-SECESSION

Caffin, Charles H. *Photography as a Fine Art*. 1901. Reprint, with Introduction by Peter Pollack. New York: American Photographic Book Publishing Co., 1972.

Sandburg, Carl. *Steichen the Photographer*. New York: Harcourt, Brace & Co., 1929.

Frank, Waldo, et al., eds. *America and Alfred Stieglitz: A Collective Portrait*. New York: Doubleday, Doran, The Literary Guild, 1934.

Doty, Robert. *Photo-Secession: Photography as a Fine Art*. Rochester, N.Y.: The George Eastman House, 1960.

Steichen, Edward. *A Life in Photography*. Garden City, N.Y.: Doubleday & Co., in collaboration with The Museum of Modern Art, 1963.

Newhall, Beaumont. *The History of Photography: From 1839 to the Present Day*. New York: The Museum of Modern Art, in collaboration with the George Eastman House, 1964.

Gernsheim, Helmut and Allison. *The History of Photography: From the Camera Obscura to the Beginning of the Modern Era*. New York: McGraw-Hill, 1969.

Green, Jonathan, ed. *Camera Work: A Critical Anthology*. Millerton, N.Y.: Aperture, 1973.

Norman, Dorothy. *Alfred Stieglitz: An American Seer*. New York: Random House, 1973.

Doty, Robert, ed. *Photography in America*. New York: Random House, 1974.

Homer, William Innes. *Alfred Stieglitz and the American Avant-Garde*. Boston: The New York Graphic Society, 1977.

Kelton, Ruth. *Edward Steichen*. Millerton, N.Y.: Aperture, 1978.

Books on the Symbolist Movement

Huysmans, Joris-Karl. *Against Nature [Against the Grain]*. Translated by Robert Baldick. London: Penguin Books, 1974. Translation first published 1959; original *A rebours*, Paris, 1884.

Symons, Arthur. *The Symbolist Movement in Literature*. New York: E. P. Dutton & Co., 1958. First published 1899, revised 1908, 1919.

Mumford, Lewis. *The Brown Decades: A Study of the Arts in America 1865–1895*. New York: Harcourt, Brace & Co., 1931.

Wilson, Edmund. *Axel's Castle: A Study in the Imaginative Literature of 1870 to 1930*. New York: Charles Scribner's Sons, 1931. Paperback, 1969.

Chassé, Charles. *Le Mouvement symboliste dans l'art du XIX siècle*. Paris: Floury, 1947.

Rewald, John. *Post-Impressionism: From van Gogh to Gauguin*. 2nd edition. New York: The Museum of Modern Art, 1962.

Chassé, Charles. *The Nabis and Their Period*. Translated by Michael Bullock. New York: Praeger, 1969. First published in France, 1960.

Jullian, Philippe. *Dreamers of Decadence: Symbolist Painters of the 1890s*. Translated by Robert Baldick. New York: Praeger, 1971. Originally published as *Esthètes et magiciens*, Paris: Perrin, 1969.

Lucie-Smith, Edward. *Symbolist Art*. London: Thames and Hudson, 1972.

Corn, Wanda M. *The Color of Mood: American Tonalism 1880–1910*. Catalog. San Francisco: H. M. De Young Memorial Museum and the California Palace of the Legion of Honor, 1972.

Jullian, Philippe. *The Symbolists*. Translated by Mary Ann Stevens. London: Phaidon, 1973.

Weintraub, Stanley. *Whistler: A Biography*. New York: Weybright & Talley, 1974.

Huyghe, René. *La Relève du réel: la peinture française au XIX siècle*. Paris: Flammarion, 1974.

National Portrait Gallery. *G. F. Watts: The Hall of Fame—Portraits of His Famous Contemporaries*. Catalog. London: Her Majesty's Stationery Office, 1975.

Fawcett, Trevor, and Phillpot, Clive, eds. *The Art Press: Two Centuries of Art Magazines*. London: The Art Book Company, 1976.

Hofstätter, Hans H., et al. *Le Symbolisme en Europe*. Catalog. Paris: Editions des Musées Nationaux, 1976.

INDEX TO PLATES